ADAM JUNIPER & DAVID NEWTON

101 TOP TIPS
FOR DSLR VIDEO

ADAM JUNIPER & DAVID NEWTON

101 TOP TIPS FOR DSLR VIDEO

101 TOP TIPS FOR DSLR VIDEO

101 Top Tips for DSLR Video

First published in the UK in 2011 by
ILEX
210 High Street
Lewes
East Sussex BN7 2NS
www.ilex-press.com

Publisher Alastair Campbell
Creative Director Peter Bridgewater
Associate Publisher Adam Juniper
Managing Editor Natalia Price-Cabrera
Editorial Assistant Tara Gallagher
Senior Designer James Hollywell
Designer Jon Allan
Colour origination Ivy Press Reprographics

British Library Cataloguing-in-Publication Data
A catalogue record for this book is available from
the British Library.

ISBN: 978-1-907579-15-8

Printed and bound in China

10 9 8 7 6 5 4 3 2 1

Contents

Introduction

Video in digital cameras is not new; most compact cameras have featured video modes of steadily increasing quality since digital surpassed film as the standard method by which we document our lives. Photographers with more sophisticated needs, however, weren't able to join the party.

That's because the first wave of Digital Single Lens Reflex (DSLR) cameras were built in a manner closely aping their film forefathers, with a mirror mechanism that reflects the image seen through the lens to the viewfinder, via the pentaprism. In the instant a photo is taken, the mirror flips out of the way and the light is exposed directly on the sensor; once the shutter is closed, the mirror returns to its position and the imaging sensor sees no light.

All that has changed now, thanks to a game-changing technology called Live View mode. Not exclusively for video, the principle is simple; the mirror is held out of the way all the time, and the light travels through the lens directly to the imaging sensor. The digital sensor can relay the image to the LCD screen on the back of the camera, allowing it to behave with the simplicity of a compact, while retaining the sophisticated interchangable lens mechanism. Indeed, some cameras forego the mirror and traditional viewfinder altogether—for example, the Micro Four Thirds system and other Electronic Viewfinder Interchangeable Lens (EVIL) systems—and much of what is discussed in this book applies equally to those cameras since all video is captured in this way.

So, that's how it works. But if it's just "something compact cameras could do" then why is it so exciting, and why was it greeted with such excitement in the photography world?

Well, for the same reasons that professionals and serious enthusiasts—like you—buy SLRs rather than compacts: quality and control. Not only the obvious advantages of so-called Full High Definition video, or 1080p as it is known, but the technology to record at high quality, through your choice of many interchangeable lenses. The latter, not available on even very costly camcorders, puts a technology in your hands that's much closer to Hollywood than was imaginable a few years a go.

This book is about how to make the best of that technology, dealing with the pitfalls—there are still some—and the unfamiliar—whether you're a photographer or a cinematographer, you're entering a whole new world—to create a masterpiece worthy of the big screen.

KEY MOMENTS IN DIGITAL VIDEO

1953 NTSC (National Television Standards Committee) introduces the color standard that remains in nearly every American home.

1963 PAL color television system is developed, addressing some of the shortcomings of NTSC and bringing color TV to Europe.

1972 For the first time, more color TVs are sold in the US than black-and-white ones.

1982 Sony introduces Betacam, the pro format which allows recorder and camera to be combined into a single unit, freeing the camera operator from a wired video recorder.

JVC's VHS-C makes compact home video cameras practical.

1960

1970

1980

1966 NASA's Lunar Orbiter program sends five satellites into orbit to map the moon. Each includes film cameras that internally process the film, digitize the images, and transmit them back to Earth electronically.

1975 Kodak builds a working prototype scanning digital camera, which takes 23 seconds to shoot a 100-line black-and-white picture and record it onto cassette tape.

1981 Sony Mavica (Magnetic Video Camera) launches; not strictly a camera, more an example of early convergence. It stored 50 still video frames from its NTSC sensor onto a 2-inch disk. Later models adopted the 3.5-inch disk popular in computers.

KEY MOMENTS IN DIGITAL PHOTOGRAPHY

The elements for true convergence photography are finally in place. In recent years, photographers and videographers alike have seen their industries revolutionized by digital technology. For the former, the biggest step was undoubtedly the replacement of film by digital sensors, while the latter saw non-linear editing (NLE) software replace time-consuming tape-based workflows. With both crafts now using similar digital technology, there is nothing to prevent crossover.

The image sensor chips in video cameras and digital stills cameras are essentially the same; the remaining differences are a matter of how the information is channeled from chip to camera, and the shape of the device. This is why most camcorders have a still frame button and most compact cameras can shoot some form of digital video.

The final piece in the puzzle came with the arrival of High Definition TV. The new HDTV standards are entirely digital—just like bigger, better quality versions of the movie clips recorded by a compact camera. All previous television formats were in some way based on the ageing interlaced system designed to be broadcast through the air and displayed as directly as possible onto a cathode ray tube.

That's not to say that there haven't been interventions—many cable companies have been using digital technology to fit more channels down their

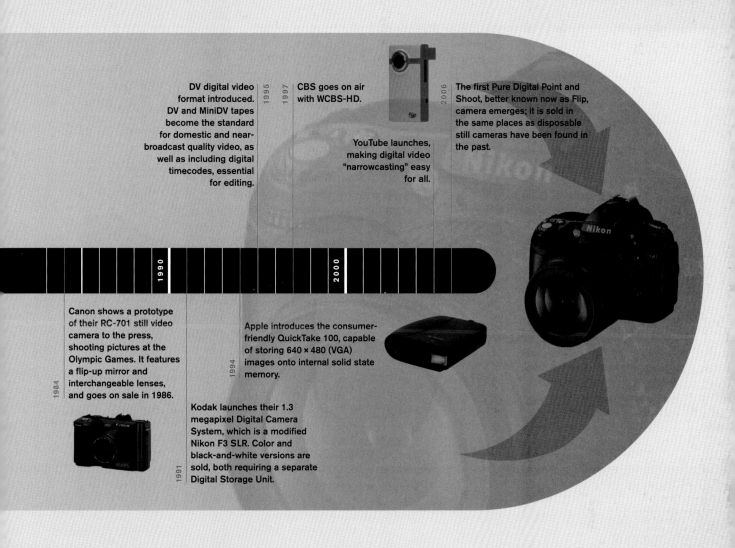

DV digital video format introduced. DV and MiniDV tapes become the standard for domestic and near-broadcast quality video, as well as including digital timecodes, essential for editing.

1995

1997

CBS goes on air with WCBS-HD.

2006

The first Pure Digital Point and Shoot, better known now as Flip, camera emerges; it is sold in the same places as disposable still cameras have been found in the past.

YouTube launches, making digital video "narrowcasting" easy for all.

1990

2000

Canon shows a prototype of their RC-701 still video camera to the press, shooting pictures at the Olympic Games. It features a flip-up mirror and interchangeable lenses, and goes on sale in 1986.

1984

Apple introduces the consumer-friendly QuickTake 100, capable of storing 640 × 480 (VGA) images onto internal solid state memory.

1994

Kodak launches their 1.3 megapixel Digital Camera System, which is a modified Nikon F3 SLR. Color and black-and-white versions are sold, both requiring a separate Digital Storage Unit.

1991

cables for years—but when they are decompressed by the cable box they are still displayed in an essentially analog way. The true HDTV systems enable the process to be entirely digital, from recording, through editing, to final display.

At the same time as digital broadcasting systems have become the norm, online sharing, or digital "narrowcasting," has been made possible since the same information can be transmitted across the internet. The only real limitation is the speed of the connection, but variations of the digital compression systems already used to fit TV signals into the airwaves or through cables have been adapted by websites like YouTube.

The result is that it is now possible to shoot video on any number of devices—camcorders, cameras, mobile phones—since they all result in digital files, but the best results can be obtained by unlocking the potential of the best sensor chips and lenses, and these are to be found in the new breed of digital SLRs.

Chapter_ 01

Technology

01

Resolution

Even in stills photography, the word resolution is one that causes a great deal of confusion, with different people vaguely applying it to terms including Pixels Per Inch (PPI), Dots Per Inch (DPI), and the camera salesperson's favorite: megapixels.

Adding megapixels to a sensor theoretically improves the resolution of the image, so long as it is printed at the same size, so an eight-megapixel image would look twice as sharp as a two-megapixel one. The measure of improvement works along a single axis, but megapixel counts are taken by multiplying both horizontal and vertical pixel measurements, so a small improvement in resolution sounds more dramatic in terms of specification.

All of this, however, is largely irrelevant in terms of video, since—unlike photos, which can have any dimensions in terms of pixels—there are recognized standards for video sizes and frame rates. They're not absolutes, of course, and in the digital age there is more and more flexibility (see Tip 2), but it makes the most sense for camera manufacturers to use established standards because they are the same ones adopted by television manufacturers and assorted media formats and players.

The standard adopted by the camera manufacturers has been what the industry calls "High Definition"—although, in the other sense of the word "definition," detail is certainly lacking in marketing terms like this. In fact, the term is used to describe a number of different formats (see box) that have emerged since television went digital.

✱ Different HD standards

720p
720 pixels (height) x 1280 pixels (wide), square pixels, 16:9 "widescreen" ratio, progressive picture refresh (whole screen per frame).

1080i
1080 pixels (height) x 1920 pixels (wide), square pixels, 16:9 "widescreen" ratio, interlaced (only every other line of the image is refreshed with each new frame).

1080p
1080 pixels (height) x 1920 pixels (wide), square pixels, 16:9 "widescreen" ratio.

2K
A film-industry format with a fixed width of 2,048 pixels and a varying vertical height dependent on resolution (for example, it would be 1,152 at a normal 16:9 "widescreen" ratio), square pixels, progressive picture refresh.

4K
Similar to 2K, with double the (fixed) horizontal width, 4,096, and (variable) vertical resolution, square pixels, progressive.

All the HD video standards use considerably fewer pixels than you'd be used to as a stills photographer; the "best" television standard, 1080p, which is loudly trumpeted by TV manufacturers, equates to a whisker over two megapixels. However, this much data many times each second is a huge amount for computers to handle, about five times the equivalent that PAL—the best of the "Standard Definition" formats—nominally processed in its digital interpretation (for more, see Tip 6).

Some of the camera's pixels will be not be used (see diagram), in much the same way that black bars are used when showing widescreen pictures on narrow-format televisions. Despite that, the imaging area is still more than double the resolution of the video standard; the camera will handle this automatically.

Just as with digital stills, lowering the resolution—say from 1080p to PAL—requires only computer processing and looks good, whereas scaling up attempts to create data from nothing and looks bad (which is why repeats of old shows on your HDTV look a bit soft).

NTSC

PAL

720p—0.92 megapixels

1080p—2.07 megapixels

4K—9.44 megapixels

1 If you assume that all the pixels are the same size, you can compare the relative areas of the different TV formats like this (though the PAL/NTSC "standard def" formats only truly have vertical resolutions). 4K is added for completeness because it's considered a cinematic standard, and has been used for Hollywood features such as *Slumdog Millionaire.*

2–4 Most of us don't have different-sized televisions for different input qualities. Instead, the apparent detail on the screen is reduced. These comparisons show a small section of the image at the same size so you can compare the effect on quality.

5 Because the proportions of 16:9 video and traditional camera sensors differ, many of the pixels at the top and bottom of the sensor will not be used.

02

Frame rates

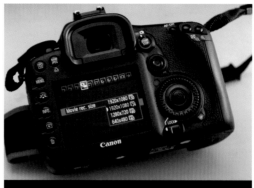

Changing the settings on a typical DSLR video mode. You can choose between high-definition modes at different frame rates or the standard definition appropriate to your region (in this case NTSC).

720p	60fps
1080i	60fps
1080p	30fps or 24fps (film)

At its most basic, a movie is made up of many still frames, and when these are played back in sequence they give the appearance of motion. The frame rate—as the name suggests—refers to the precise number of frames captured per second while you are shooting video.

Traditionally this subject was relatively straightforward. There were three basic speeds: 24fps (the long-standing cinematic standard), and 30fps/60Hz or 25fps/50Hz for the two major TV systems (see Tip 3). You knew your target in advance and shot appropriately.

In switching to HD, television manufacturers have preserved the standard frame rates of the past (it makes it a lot easier to show repeats or shows captured with older technology alongside the shiny new HD stuff), but there is a twist. The newer HDMI connectors between TVs and video-playing devices like Blu-ray players and cable TV boxes mean that the units can communicate, exchanging information about which standards they support, making it easier and faster for companies to add new standards.

Moreover, a high proportion of video never leaves the computer screen, and computers can effectively display any frame rate they're asked to. That means you can call something video even if it doesn't adhere to one of the traditional frame rates (indeed, many online videos rarely reach 30fps).

Proving the flexibility of digital, Canon added a 1080p shooting mode to their T1i DSLR (500D) by compromising on the frame rate, which was reduced

to 20fps, four below the traditional cinematic standard. Cynics might suggest that the motivation was to get "1080p Video" on the spec sheet, but regardless of the motives the point is that this area is somewhat flexible.

When you're editing your video work together, though, unless you're creating slow motion it is much better to choose a single frame rate and stick to it. 24fps and a progressive-scanned resolution will go well with film fanatics.

❋ Interlacing

Almost compulsory in the past, interlacing was a great way to improve the apparent quality of a video signal without widening the signal transmission bandwidth. It is the root of the 30fps/60Hz difference televisions; at NTSC's stated resolution of 480 picture lines, 30 frames are shown each second, but in practice only half of the frame is updated with each refresh—every other line of the picture—so there are 60 half-frames per second.

In this series of frames, the eye moves quickly from one position to the next. In the central frame, the interlace shows the motion, as the most up-to-date field has the eye farther to the right.

03

NTSC and PAL

NTSC and PAL are, at their core, broadcast television systems and the two major standards used in the world (SECAM is a far less prevalent third). They are hangovers from the analog era, when the "data" for the signal, the color, and in some cases the audio data, were packaged separately and attached to a radio wave for transmission.

In a digital broadcast system all of these components are typically packaged in a single file, but there are still many hangovers from the

To see the movie, visit:
http://www.web-linked/vidt/01/

NTSC/PAL era, not least the declining but still dominant TV standard in the home (even if people own HD-ready TVs, they're often still only watching NTSC or PAL pictures).

The first hangovers are the dominant frame rates. These come from an age where electronics were heavily susceptible to interference, so the refresh rate for the picture was set to match the frequency at which AC electricity came from the outlet—60Hz in the US, 50Hz in Europe. The frame rate was also dictated by the technology; in the early days there were limits on the speed at which the beam of cathode rays could be scanned onto the tube and show an image, and using two cathode rays interlaced improved this situation.

In the analog era, the horizontal "resolution" was effectively the amount of detail that could be squeezed through the air as the CRT scanned across the screen, drawing the image as it went. For digital devices which connect to TVs, this has meant that, to achieve maximum quality, narrow rectangular pixels were used (see Tip 100).

NTSC and PAL have also seen a change from the traditional TV shape, 4:3, to the more filmic 16:9 "widescreen" foisted upon them. In this case nothing serious about the technology was changed: the widescreen variant—known as anamorphic widescreen—was simply created by changing the horizontal dimension of the screen; in computer terms, the horizontal width of the pixels.

04

Containers and wrappers

A container, or wrapper, refers to the file format in which encoded data is held. There are many types of file format and most have specific purposes associated with specific computer programs. Some are created for a specific type of data—such as TIFF files, which only hold still image data—while other, multimedia containers can contain different kinds of data. The MOV file format, for example, is the standard QuickTime container developed by Apple, and the file type used by Canon DSLRs to shoot HD video, while Nikon cameras use the Microsoft-developed AVI file format instead. What both have in common is their ability to hold still images, moving images, audio data, or even a combination of all three.

Once you have chosen your camera, you have no choice over which file format is used to record your movies, as this is determined by the manufacturer. However, different containers have individual strengths and weaknesses, which can make a difference to the data it stores: the AVI container, for example, does not support features such as Variable Bit Rate (VBR) audio, meaning that any audio data will require more storage space.

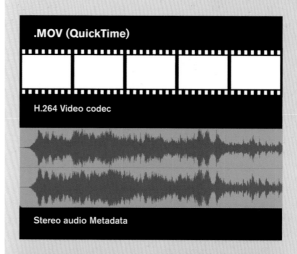

.MOV (QuickTime)

H.264 Video codec

Stereo audio Metadata

.MOV (QuickTime)

H.264 Video codec

Mono Metadata

.AVI

Motion JPEG

Mono Metadata

05

Codecs

If the container is the "box" in which data is held, the codec is the bit that orders the data and packs it into a nicely coded arrangement. The term "codec" is derived from two words—*compressor* and *decompressor*—which describe its ability to encode and/or decode the data in a file. There are essentially two types of codec—lossless codecs that compress data without losing any information, and lossy codecs that will compress the data, but discard some information in the compression and decompression process.

In the same way that some containers are better suited to different types of content, so some codecs are designed to work better with certain tasks than with others. For example, the H.264 codec achieves high video quality at lower bit rates than some other codecs, but uses more processing power to achieve it. The result is that, while the codec works well for fitting data on the memory card or simply playing back video, it is not well suited to editing software as it takes more computing power to simply show the moving image, before you take into account transitions and other features.

Many video-editing systems work far more smoothly if the video is converted to a codec specifically designed for editing; these will have their data arranged to make it easier for the computer to display, but will likely require larger files. In Final Cut Pro the Apple ProRes codecs allow editing in real-time without having to wait for transitions to be rendered before playback.

Codec conversion

There are several software programs that allow you to convert one codec to another, but one of the best is the free program, MPEG Streamclip. Produced by Squared5 (www.squared5.com), it is available for both Mac and Windows.

06

Aspect ratio and composition

Whether you're shooting a still image or a movie, the aspect ratio refers to the ratio of width to height. The standard-definition format for a television screen is 4:3, but in recent years widescreen has taken over, and HD footage conforms to the widescreen shape of 16:9. To simplify the concept, think of the numbers as a measurement unit; inches, for example. A 4:3 aspect ratio image would be 4 inches wide and 3 inches high, while if the image was 16:9 format, it would be 16 inches wide and 9 inches high. The ratio doesn't mean an image or movie has to be exactly these sizes, it just refers to the relative width to height. You could, for example, have an image that was 8 inches by 6 inches and this would still be in a 4:3 ratio.

In digital movie terms, the three recording sizes generally available on a DSLR are measured in pixels, but will still conform to either 4:3 or 16:9—both 1920 x 1080 and 1280 x 720 are 16:9, while 640 x 480 is 4:3. If you film a movie clip in high definition at a 16:9 ratio, then play it back on a standard-definition television, you will see letterboxing at the top and bottom of the screen. This is so the full 16:9 picture can be contained within the 4:3 ratio. Occasionally, you may also see video that has been cropped or stretched to fit a screen, which can distort the image.

When shooting video and/or using a 16:9 format, the compositional rules you use for stills shooting are equally relevant. This includes the rule of thirds, which will be somewhat vertically squashed, but works just as well as a guideline to placing subjects in your frame. Part of the beauty of the 16:9 format is the wider view—the "widescreen experience"—and to make the most of it you need to take care not to put your subjects in the center of the frame, especially if it's a small subject. This is because there will be a lot of "dead" space to either side that will be wasting most of the frame. Although the amount of space will be increased if you position your subject off-center, the composition will be stronger, allowing you to balance the subject and its surroundings.

If you're not certain where or how your film will be shown, then you may need to keep the 4:3 ratio in mind as you frame your shots. You can still shoot using a 16:9 aspect ratio, but if there is a chance your film may be shown in 4:3, you should avoid placing any visually important information at the very edges of the frame, to reduce the risk of it being cut out in the conversion. If, however, you will always be showing your films in widescreen, this doesn't apply and you can make use of the whole frame.

If you want to be very clever with widescreen framing, you can make use of it to show two different shots at the same time—a close-up on the left and a mid- to wide shot on the right, for example. This can be done by simply working with the aperture and depth of field and the camera-to-subject distance. With a 4:3 ratio this wasn't possible because the close shot would fill most of the frame, leaving little space for anything else.

1 Although for the most part you will only experience shooting in 16:9 "HDTV" mode, it's worth comparing it to the classic television format and the wider cinema format used in some feature films.

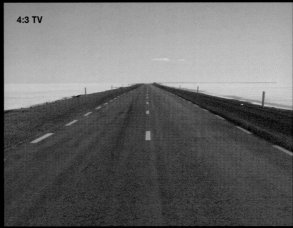

4:3 TV

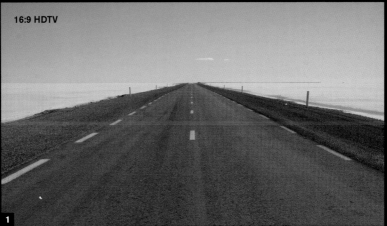

16:9 HDTV

1

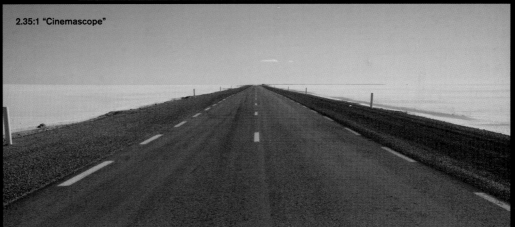

2.35:1 "Cinemascope"

2 It's possible to achieve the cinematic width in post-production by adding black bars over your picture, though you'll have to bear this in mind when shooting. Note that the shape is still 2.35:1, but the image here is a crop of the view the 16:9 mode sees.

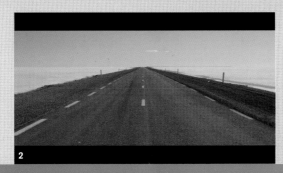

2

07

Connections: HDMI and USB

HDMI stands for High Definition Multimedia Interface—an industry standard connector and cable for transmitting digital information from one component to another. It was designed to be a digital replacement for longstanding analog connectors such as S-Video, coaxial, and (largely European) SCART cables, and is used to connect High Definition display devices with input sources. Unlike traditional analog connectors, it is digital, so the device—your camera—and your television will electronically handshake and determine the best possible display of your pictures.

Using the HDMI connector is much like using any other TV display method—you can use it to play back movies from your memory card, or monitor while you're shooting.

USB remains the standard interface for transferring files from camera to computer, so if you don't have a card reader you can hook up your camera to your computer and turn it on; it will be recognized by the machine either as a USB drive or—if you have cataloging software such as Lightroom or Aperture installed—as a camera from which images should be copied and organized.

The USB cable performs another function: many cameras now feature a PTP mode which allows them to communicate directly with output devices—printers, or portable displays like Apple's iPad. Indeed a common problem when connecting to a computer is that the USB communications mode was accidentally set to PTP—you can check this in your camera's menu.

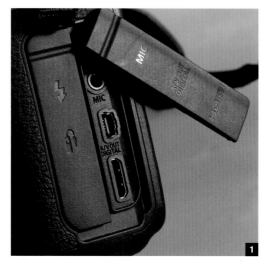

1 The HDMI port (among others). Note that opening the protective seal to one affects all of them. Keep the others covered with tape in bad conditions.

2 An HDMI cable.

08

Firmware updates

DSLR cameras are complex electronic systems—a mix of hardware and software that is integrated to allow us to take pictures and shoot HD video. While the hardware in a camera is "fixed" when it's manufactured, the software—referred to as *firmware*—isn't, so it can be changed and updated. Making sure you are using the latest firmware can make a significant difference to the way a camera functions. For example, while most firmware updates are used to fix minor bugs, or fine-tune certain features, Canon used it to make a radical change to the way its EOS 5D MkII behaved. With nothing more than a firmware update, the company introduced manual exposure control to the HD video recording mode so users could set the shutter speed, aperture, and ISO—a significant advance in functionality, but one that no one needed to pay for.

You can check the firmware version that your camera is using via the camera menu, and all DSLR manufacturers have the latest firmware for their cameras available on their website: simply download the file and follow the instructions given on the website. Typically, that process involves copying the firmware update onto a memory card, placing the card in your camera, and following the onscreen instructions, but this may vary.

✳ Firmware update safety

✳ Always use a fully charged battery or AC connector when you are updating the firmware to make sure your camera doesn't shut down during the update. If it does, the firmware may not be installed correctly and you could be left with an expensive paperweight.

✳ During the update, do not touch any buttons or controls on the camera.

09

Memory cards

1 Memory card slot in a typical DSLR.

When 4 GB of storage only provides you with around 12 minutes of footage (see Tip 11), shooting HD video will consume your memory card space much faster than when you shoot stills. So, if you're serious about shooting video, consider 8 GB capacity cards as the absolute minimum.

The speed of your cards is equally important, as shooting movies produces so much data that it's easy for the camera's buffer to fill up—more so than shooting a high-speed burst of stills. To avoid any form of buffer lockout, your memory cards should feature a write speed greater than 8 MB/sec or 60x (the equivalent of 9 MB/sec).

Achieving the fastest download speeds to your computer will also require a fast memory card reader, so look for one with a high-speed connection such as FireWire 800 or, if you have an ExpressCard slot in your computer, an ExpressCard reader.

Formatting

There are two ways of clearing data from a memory card: deleting and formatting. If you want to clear the card completely, it is much better to use the Format command than a Delete All option, as formatting is not only quicker, but it is also better for the long-term life of the memory card.

This is because data is stored on a memory card in sections, along with an "index"—the File Allocation Table, or FAT—which tells the computer or camera where the data is stored on the card. If you use the Delete All command, the files are deleted, but not

the FAT table, which will simply be added to as you shoot more images or footage. Over time, this means the FAT table can easily become a jumble of entries, potentially leading to problems accessing files or even a total failure of the card.

Formatting your card, on the other hand, not only removes all of the files, but recreates the FAT table to help the card keep track of data more efficiently. Formatting will also write any camera-specific data to the card, which is especially important if you use several different cameras; a card formatted in one may not always work in another.

2 16 and 32 GB capacity CompactFlash (CF) memory cards. CF cards have long been the preferred standard for high-end cameras, and the more portable SD format for consumer models.

3 A memory card reader.

4 The formatting process being carried out in-camera.

10

In-camera processing

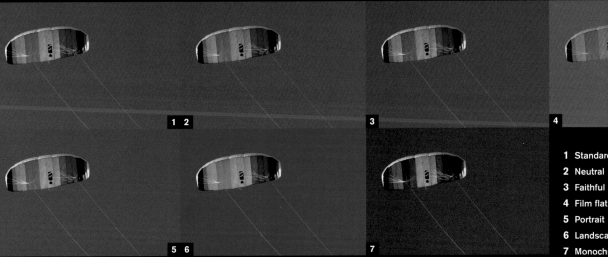

1 Standard
2 Neutral
3 Faithful
4 Film flat
5 Portrait
6 Landscape
7 Monochrome

When you are recording movies on your DSLR, you should treat them as you would a JPEG file when you are shooting stills. Like a JPEG, it is much harder to process movie footage after you have shot it. Whichever DSLR camera you are shooting with, you will have access to a wide range of parameters that can be used to adjust the appearance of the footage—saturation, contrast, color, and sharpness, for example—and you should take the time to experiment with these as they can make your life much easier at the post-production stage.

If you plan on making nothing more than a quick video of your children running around the park, chances are you will not want to be too heavily involved in post-processing and color correction, in which case you can choose one of your camera's presets and use it for all of your filming. On Canon's EOS cameras these presets are called Picture Styles, while Nikon SLRs call them Picture Controls, but regardless of the name they are essentially

similar ways of achieving a predefined "look"— neutral, vivid, landscape, portrait, and so on.

If you plan on making a movie masterpiece and want greater control in post-production, the best approach is to stay away from the vivid or saturated settings and use one that gives a fairly flat result. As the black and white points will be less compressed, the dynamic range of the footage will be maximized, meaning it will respond better to post-processing. The easiest option is to use your camera's Neutral style or, if you are feeling very creative and the software provided with your camera allows it, you can create your own profile.

11

Clip length limits

At the time of writing, DSLR cameras record much shorter video clips than dedicated video cameras, although as the technology improves this is sure to improve. In Full HD shooting, for example, the maximum clip length you can record ranges from 5 to 12 minutes, depending on the camera you are using, but shooting in non-HD mode—at 640 x 480 pixels, say—will allow you to shoot almost 30 minutes of footage with some cameras.

This limitation is due to the large file sizes associated with HD video, and also to memory card formats. In a DSLR, the memory card uses the FAT32 file format, which allows a maximum recorded file size of 4 GB. As HD footage works out at roughly 1 GB of data for every three minutes of recording, the 4 GB file size limit equates to about 12 minutes of footage at most. (See Tip 38 for reasons why this is not a problem in most shooting situations.)

The reason it is "about" 12 minutes is because the actual file size will be determined by what is recorded in the scene. If you have a scene with little detail, or a muted color palette, you may find you can achieve more than 12 minutes of recording, as the file can be more easily compressed. However, if the scene is full of detail, the file won't be compressed as much, so you will likely achieve less than 12 minutes for your clip.

At the same time, it is important to understand that the 12-minute clip length does not mean that is all you can fit on the memory card—it is simply the

maximum duration you can record as a single clip. Once you reach the 4 GB limit, you can immediately start recording again. So, if you were using a 16 GB card, you could fit four 12 minute clips on the card, or 48 minutes of footage in total.

✳ Silent shooting

If you want to record clips that are longer than 12 minutes, switching off your DSLR's sound recording is a simple solution, as it will allow the 4GB data limit to be filled solely by video, without any additional sound information. However, if you are recording voices, or you require the sound to synchronize precisely with the video, you are advised to keep sound recording turned on so you can use the audio as a guide track to sync to.

✳ Shoot a dust map

To check for dust, you need to shoot a "dust map," which is essentially a defocused shot of something bright—a white card or the sky, for example—that shows up the dust on the sensor.

To do this, fit the longest focal length lens you own to the camera, switch to manual focus, and focus as close as the lens will allow. Choose aperture-priority mode, set the smallest aperture you can (f/22–f/32, for example), and then take a picture of the sky, or your white card. Don't worry about the shutter speed, as everything will be out of focus anyway.

You will now have a dust map image that you can open up on your computer and check for the appearance of dust. If there isn't any dust, then you don't need to clean your sensor. If there is, you can use your dust map as a reference.

12

Sensor cleaning

With the camera set to mirror lock-up mode and the lens removed, you have access to the camera sensor, where dust gathers.

Dust is a perennial problem for photographers, and it seems that no matter what you do, or how hard the manufacturers try to prevent or remove dust, it still gets into your camera and appears as defocused blobs all over your images. If you shoot stills, it's relatively quick and easy to edit dust out of your images using your editing program's Clone Stamp or Healing tool, but with video it is much harder to remove dust from your footage after the event. This makes it imperative that your sensor is dust-free before you shoot.

Most camera service centers will clean your sensor for you, but you can also clean it yourself, and there are lots of kits you can buy to help you. However, there is a risk involved, so if you are at all uncertain about your ability to do it, the simple advice is to take it to someone else—the last thing you want to do is damage your camera. The main thing to remember is to take your time: don't rush.

The first step is to check for dust on your sensor, and the best way to do this is to shoot a "dust map"—a picture, at narrow aperture, of a plain surface (see box). Assuming there is dust present, then you need to arm yourself with the necessary cleaning tools. There are various methods of sensor cleaning, but the ones I use (in order of their invasiveness on the camera) are: blower bulb, dust brush, and sensor swab. You will generally need to invest in at least a couple of these to keep your sensor clean, as it's very rare that one alone will clean a sensor perfectly.

Always start your sensor cleaning with the least invasive method—the blower bulb—and go from there. It's vital you make sure the camera battery is fully charged, then enter the sensor-cleaning mode and hold the camera so the lens opening is facing downward. Blow upward into the chamber with the blower bulb a few times, then turn the camera off to close the shutter and shoot another dust map to see if your sensor's been cleared. About 90% of the time, this will be enough to get rid of your dust and, if it is, great! If not, move on to a dust brush, taking your time and following the instructions that came with it. This will generally get rid of the vast majority of dust, so the only time you need to use a sensor swab is if you have "sticky" dust globs that don't simply blow away or lift off.

If you have to move on to swabbing, it is imperative to follow the instructions very carefully—only use a couple of drops of cleaning fluid on the swab, and don't wipe the sensor with the "used" side of a swab. The best tip for using swabs is to pick a swab kit that is one size smaller than your camera sensor (choose an APS-sized swab kit to clean a full-frame sensor, for example). You will use more swabs to clean the sensor, but the smaller head makes it easier to remove dust from the corners, rather than just sweeping it there to accumulate.

Finally, if at any stage you get down to just three or four small specks of dust, stop! You will never remove all of the dust, and if you keep trying, you're likely to make things worse.

A bulb blower can be used to remove dust.

13

Standard lenses

1

A standard lens refers to any focal length that has roughly the same apparent scale when viewed through the lens as the scene does when seen with the human eye. With full-frame sensors this is a 43mm focal length (although 50mm is broadly considered standard), while a focal length of 21–30mm is closer to the standard field of view on a smaller, APS-sized sensor. Although it's generally best to try to use a variety of different focal lengths during your film, if there is one lens that you could comfortably make use of for an entire film, it would be a standard lens.

This is not the same thing as lifting the camera to your eyes and seeing your entire angle of view; to do that you'd need a very strong fisheye lens, as you have a great deal of peripheral vision. Instead the "normal" lens keeps the perspective looking the way you expect.

Because the focal length of a standard lens closely matches the way we see with our eyes, it provides a perspective that seems natural to us—everything appears as it should be. This makes it the ideal focal length to use if you want to shoot sections of your movie in a "point-of-view" style (see Tip 34) as it helps the viewer imagine they are witnessing the action through their own eyes.

But this is not to say that a standard lens is *only* good for point-of-view shots. Standard prime lenses (fixed focal length lenses, not zooms) are often

quite cheap compared to other lenses in a manufacturer's range and they also tend to have fast maximum apertures, making them useful for shooting in low light. Both Canon and Nikon produce prime, 50mm, f/1.8 lenses, for example, and at under $150 they are ideal if you want a fast lens that can restrict the depth of field.

If you plan on making use of fixed focal length lenses, you should be aware that they are harder to use than zooms. Because the focal length is fixed and similar to the view our eyes have of a scene, you have to work harder when it comes to composition and shooting angles to get the best out of them. It's worth experimenting with your shooting position by getting up higher or down lower to add drama to the scene or create a slightly different look to the "standard" view.

1 This frame was captured with a 50mm EFL lens. The field of view is very natural.

2–3 Remember that the 43mm EFL setting is usually within the range of the standard kit lens supplied with most cameras, so you can experiment with the framing without investing in a new lens. This lens, for example, is a 17–85mm lens on a camera with a crop factor of 1.5, so the EFL range is 25.5–127.5mm.

2 3

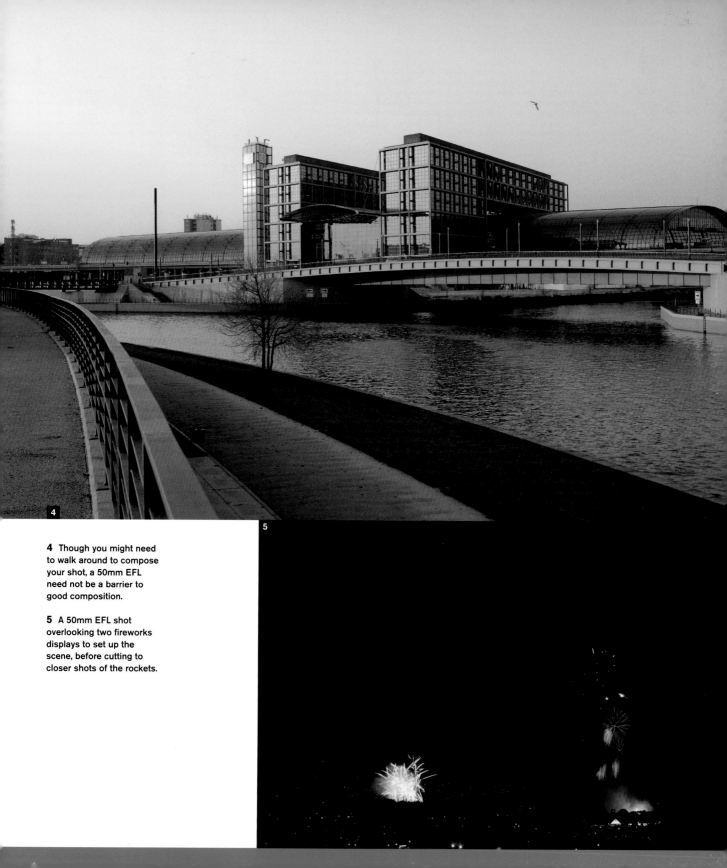

4 Though you might need to walk around to compose your shot, a 50mm EFL need not be a barrier to good composition.

5 A 50mm EFL shot overlooking two fireworks displays to set up the scene, before cutting to closer shots of the rockets.

14

Telephoto lenses

Technically speaking, a telephoto lens is any lens in which the physical length of the lens is less than the focal length, but more commonly it's taken to mean a lens with a focal length of 100mm or more. At its most basic, a telephoto lens allows you to bring distant subjects closer, or concentrate attention on a small area of a subject to add impact or avoid distractions. At the same time, the perspective a telephoto lens gives will appear to "compress" a scene so that distant subjects seem to be stacked on top of each other, giving the viewer fewer visual clues about how far apart different subjects are.

In addition to telephoto lenses, there are "super" telephoto lenses which have a focal length of 300mm or more. Super telephotos are ideal for wildlife film-making as they allow you to film distant, shy, or dangerous wildlife without getting too close, but their long focal length can also be used creatively to enhance the telephoto compression effect even further.

However, telephoto lenses of all types have one thing in common—their ability to make a subject stand out against a defocused background. By getting as close to your subject as the lens's focusing will allow and selecting the maximum aperture possible—$f/2.8$, for example—you will achieve the shallowest depth of field possible and, as long as your subject is a little way from the background, you will create a very soft, out of focus background that can really help concentrate the viewer's attention.

The opposite side of the coin is that a telephoto, like any other lens, can be used at a very narrow aperture (high f-number), which will result in objects near and far all seeming in clear focus.

1 A telephoto lens, especially a good one, can be quite big—and also rather heavy.

1

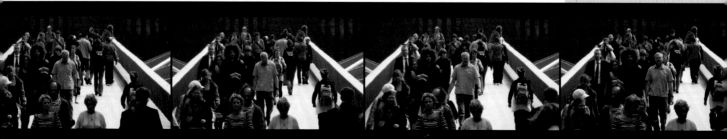

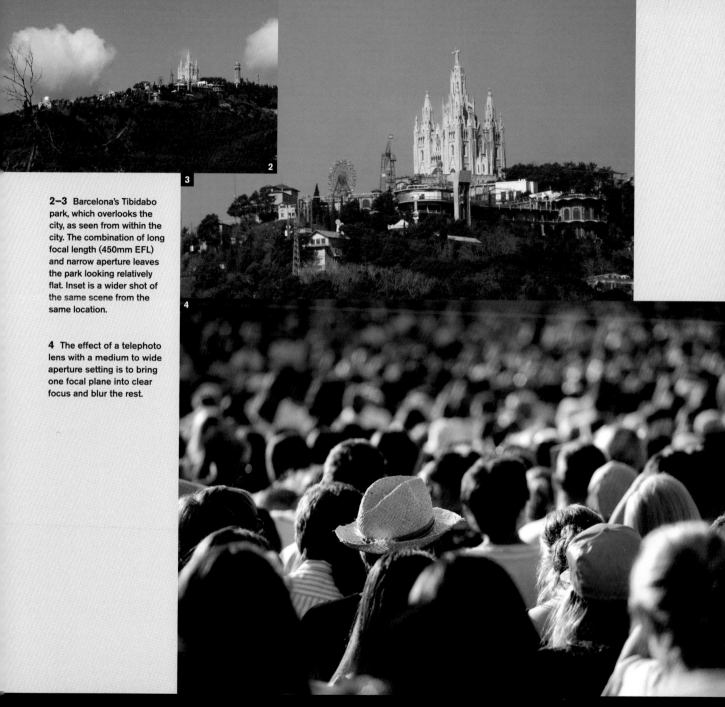

2–3 Barcelona's Tibidabo park, which overlooks the city, as seen from within the city. The combination of long focal length (450mm EFL) and narrow aperture leaves the park looking relatively flat. Inset is a wider shot of the same scene from the same location.

4 The effect of a telephoto lens with a medium to wide aperture setting is to bring one focal plane into clear focus and blur the rest.

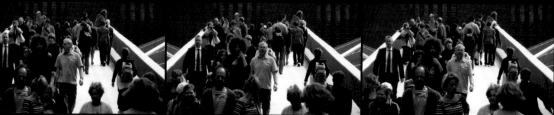

A telephoto lens has a foreshortening effect. In this sequence it condenses all the pedestrians walking across the bridge into one small, surprisingly flat-looking area.

15

Tilt-and-shift lenses

Tilt-and-shift lenses are specialized lenses that were originally designed for shooting architectural subjects. They allow you to control perspective so vertical lines are rendered vertical rather than appearing to converge. This is not their only use, however, as they also allow you to manipulate the plane of focus and depth of field. In still landscape photography, for example, a common technique is to tilt the lens downward to increase the depth of field at any given aperture. However, when they're used for filming, a reverse tilt—that is, tilting the lens backward—can be used to restrict the depth of field instead. This can make a subject look almost as if it's a small-scale model, especially when the shot is combined with a high vantage point that exaggerates the idea of "looking down" on a miniature world. As with any technique, it's easily overused, but it is still a way of producing a look that is not easy to create with a traditional video camera, and can make your production look more exciting.

When you're using a tilt-and-shift lens, you should always take your time. Don't rush into filming until you've made sure that the tilt and shift movements are exactly where you want them to be. It's often useful to film a short clip and review it on a larger screen or monitor before you start filming properly.

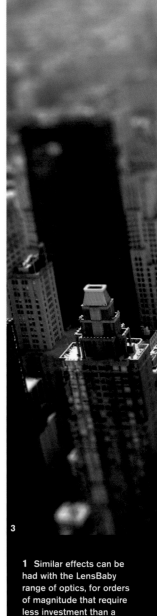

3

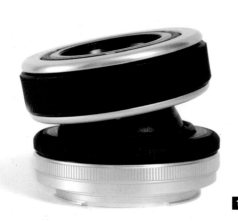

1　**2**

1 Similar effects can be had with the LensBaby range of optics, for orders of magnitude that require less investment than a traditional tilt-and-shift lens.

2 Professional-grade tilt-and-shift lenses include detailed controls.

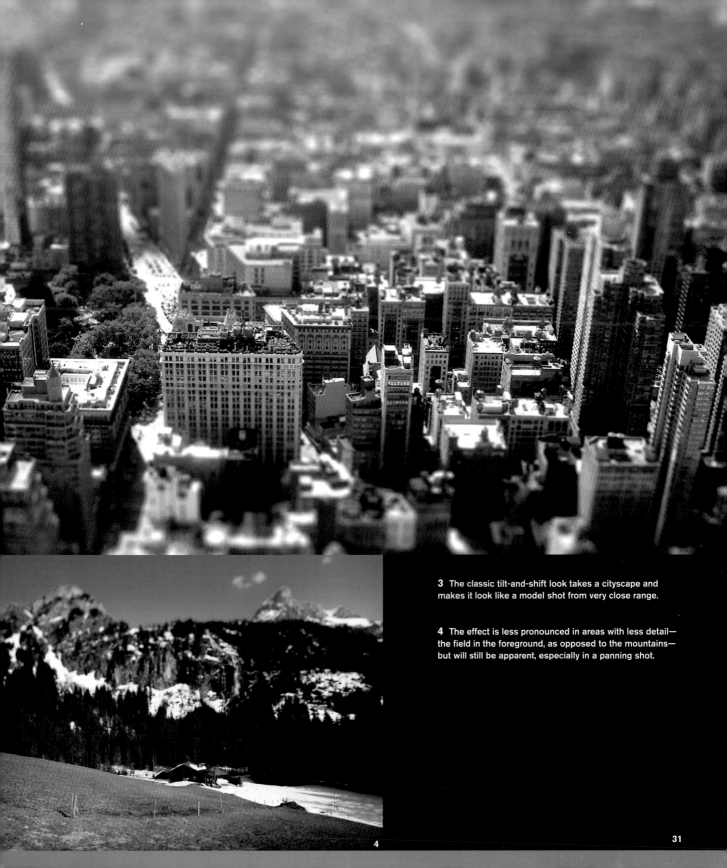

3 The classic tilt-and-shift look takes a cityscape and makes it look like a model shot from very close range.

4 The effect is less pronounced in areas with less detail— the field in the foreground, as opposed to the mountains— but will still be apparent, especially in a panning shot.

4

16

Fisheye lenses

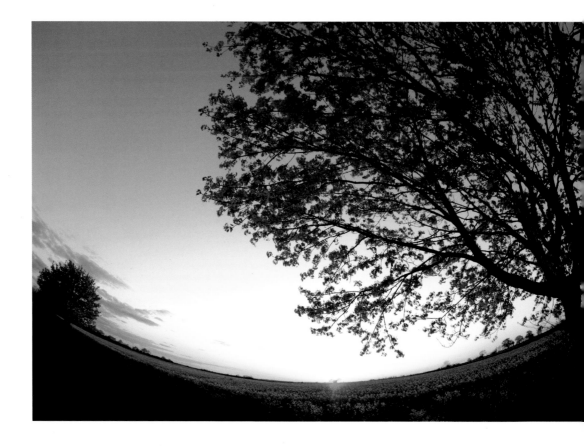

One of the advantages of shooting movies with a DSLR instead of a standard video camera is the ability to use a wide range of lenses—if a lens works for shooting stills, it will work for shooting HD video. This gives you access to a whole host of creative optics, including fisheye lenses. A fisheye lens is so called because it provides a very wide angle of view that is typically curved at the edges, mimicking the sort of view a fish has. With a field of view of up to 180 degrees, fisheye lenses let you capture a huge area in front of the camera, although to get the most dramatic effect you will need to use a camera with a full-frame sensor—fisheye lenses will work with APS-sized sensors, but the smaller sensor size will narrow the field of view and diminish the fisheye effect.

While you wouldn't want to use a fisheye lens to film an entire movie, using one creatively for certain shots can enhance a production and give a fantastical, almost surreal look to a specific scene. This is particularly dramatic if you pan the camera when there are straight lines in the scene, as the distortion of the lens will curve the lines strongly at the edge of the frame, visibly straighten them as they pass the center of the frame, and then increase the curvature as they move toward to opposite side of the frame.

If you plan to use a fisheye lens, you need to be quite careful with it—while the distortion is part of the creative pleasure, the extremely wide field of view means you need to check the frame to make sure no undesirable elements have crept into the frame—twigs, people, or even your own feet!

The curved effect of a fisheye lens is often used in time-lapse clips.

17

Creative optics

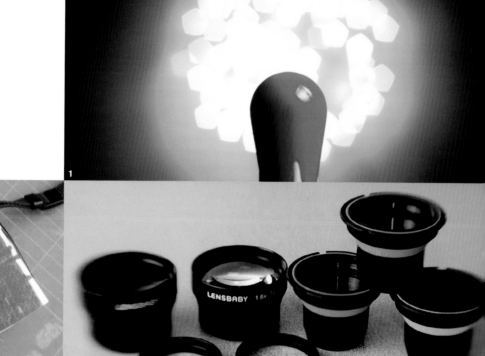

1

2

3

One of the greatest things about the SLR over compact cameras has always been the ability to add a touch of creativity to your shooting. There are many exciting ways that you can affect the optics of an SLR that are much harder, or impossible, to achieve with smaller cameras. These techniques can be applied to video too, depending on your camera.

Such techniques include manipulating the bokeh (a Japanese word used to describe the quality of the out-of-focus areas of an image), or perhaps even experimenting with freelensing.

The classic way to affect the bokeh is to cut a shaped hole into a piece of black card, then hold it over the center of the lens when shooting.

Freelensing is a term used to describe detaching your lens from the camera mount, then holding it closely against the mount at a slight angle to create

an interesting effect. This might not be a great way to conduct an interview, but as a method of creating an unusual, moody or creative shot, it's well worth experimenting with. In video mode it'll be more difficult, as you'll need to find a way to steady the lens, but that's no reason not to try.

There are also commercially available creative optics, like the interchangeable attachments that form LensBaby's Optic Swap System. This is a way to add a little more control—in the form of properly machined lens mounts—to a variety of non-traditional looks, including a plastic lens that creates results which the Lomography crowd would be proud of, and a double-glass optic that provides a blurry halo around a sharply focused subject.

1 A classic example of bokeh, with the defocused specular highlights behind the match head creating shutter-blade shapes.

2 A home-made heart for creating bokeh effects.

3 Some of the optic-swap lenses for LensBaby's interchangeable system.

Music Video / James Karinejad *Strange Fruit*

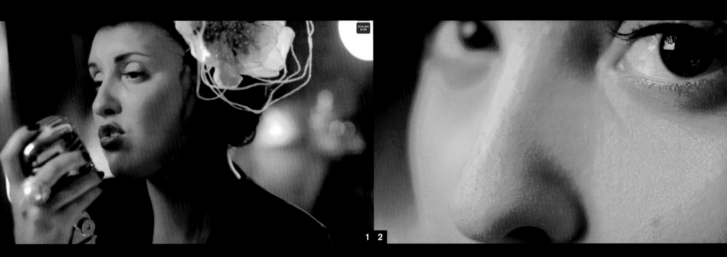

1 2

I was a Camera Assistant for Directors of Photography, shooting feature films, commercials, and music videos on a range of formats—35mm, 16mm, HD Cam. You name it, they've shot on it and I've loaded it! I took photography more seriously after a producer on a feature film saw I was snapping away while on set. I was the clapper/loader and in between takes I would capture all the action that was happening, both on and off set.

I now have a small studio in North London and work as both a photographer and DoP. So as you can imagine the arrival of the HDSLR has been warmly welcomed.

Edmund Curtis, a fellow DOP, approached me with the *Strange Fruit* project. "Are you free next Friday to shoot a music video?" Days later Edmund was at the studio to discuss the shoot. Our brief was to shoot a music video highlighting the

skills of make-up artist Nisha Smith. Nisha wanted a visual representation of her work that was different from the usual photographic portfolio. She had teamed up with singer/songwriter Emma Michelle and were set on using her cover of Billie Holiday's song *Strange Fruit* for the video.

Initially Edmund and I sat down to discuss what we wanted the video to look and feel like. We wanted to utilize one of the key features of the DSLR, the shallow depth of field. We went through our kit and between us both made a list of what we had. I had the lights and lenses, the 50mm 1.2L and the 100mm 2.8, and Edmund had the slider, monitor and handheld shoulder mount. Together we had all the gear needed to make a great-looking video. Although it was a music video, the recording of high-quality sound on set was not a priority, as the audio recorded

in-camera would only be used to help sync the video with the professionally prerecorded audio track.

We agreed that we'd shoot fairly wide open to achieve the desired shallow depth of field. The 50mm at $f/.2$ would be too shallow and make focusing extremely difficult so we aimed to shoot between $f/2.8$ and $f/4$. We'd also shoot using the native ISOs—160, 320 and 640—as anything in between would be noisier. According to tests done by Zacuto, shooting at 100 ISO is noisier than using the native ISO 160. In a studio we can control the light levels, so we aimed to shoot at $f/2.8$ with an ISO of 160.

Billie Holiday first recorded her song in 1939. Immediately Ed and I were thinking of a 1940s or '50s style of film and realized the importance of the set that we were to shoot it in, the *mise-en-scène*.

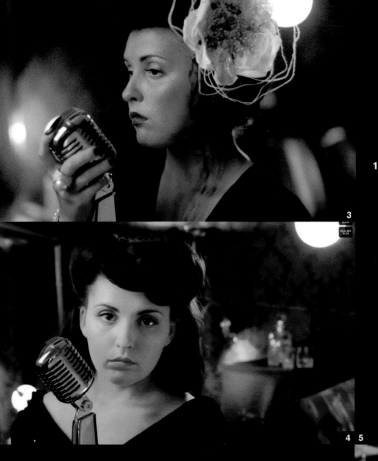

1–6 Stills from *Strange Fruit*.

3

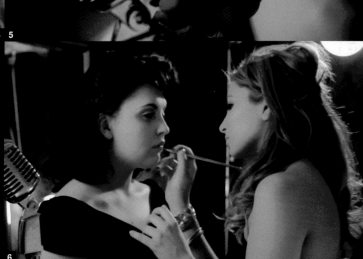

4 5

6

My studio is modern with white walls, far from how we imagined the look and feel of the video. This was the first obstacle—one which, on a larger shoot, would have been the job of a set designer, but for us became the job of the DoPs. An HDSLR shooter has to become a jack-of-all-trades if they want their videos to stand out.

After a trip to a DIY store we came back with rolls of vintage-style wallpaper that would be used to add some color to the studio walls. Edmund and I sourced numerous objects, including a large, gold-framed mirror from my living room, a lamp from his place, and purple cushions to try and make the set feel right.

For the lighting we used the modeling lamps from photography flash heads. They output approximately 250 watts of light and that was more than enough for our small set. Emma's key light was the lamp

Wallpaper was hung over the otherwise white studio.

2–3 Shooting using a hand rig.

4–5 The crystal glass was lit overhead using a standard light and snoot.

6 Filming.

7 "And that's a wrap."

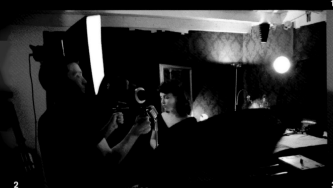

1

2

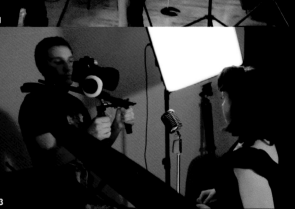

3

with a square softbox on the front, something stills photographers would be more familiar with. This provided us with a soft, warm light that could be controlled quickly and easily with the dimmer on the flash head. Emma's backlight was another 250 watt modeling lamp with a wide-angle reflector placed directly behind her. This separated her from the background and was placed on a boom arm, as we wanted this light to be partly in the shot but the lighting stand to be out of frame. Emma's fill light was a golden reflector that bounced the light from the backlight onto the right side of her face. So far this is all the type of equipment that you'd find in a photographer's lighting kit.

Now came the obstacle of lighting the set. We were limited by space but wanted to create a feeling of depth. We overcame this in two ways. First, by utilizing the fast

speed of the lenses, shooting at $f/2.8$, creating a shallow depth of field. Second, by putting practical lamps in the frame that would fall out of focus due to the shallow depth of field. The practical lamp may only be a meter away, but on camera it will appear farther away. Also, because we were shooting at $f/2.8$, most practical lamps that you would have sitting around the house would be bright enough to be used. We experimented with fairy lights, desk lamps, and other photographic lamps.

This was the most time-consuming part of the shoot, but we knew that once we got the lighting right, then very little would have to be changed for the rest of the shooting day. In addition, with two DoPs shooting the video, perfectionism was uppermost in our minds—and there was no 1st AD (assistant director) to keep a time check on us!

Once the set had been dressed, we were ready to shoot. We were shooting the entire video in one location so we had to be careful to not bore the viewer with three minutes of repetitive shots. To avoid this we used a selection of static shots, tripod shots, and moving shots, both handheld and on a slider track. In my opinion the tracking shots are what really make the video a success. We placed the meter-long slider on two tripods, one at each end. On the slider we placed the Manfrotto 501 fluid head, which is perfect for use with a DSLR. Getting perfectly smooth shots with the slider takes a bit of practice and making sure it is level is essential, otherwise you get areas of friction as you move the sliding plate from one end to the other. When using the slider, I found it helpful to take a firm stance in the end position of the movement, then slide the

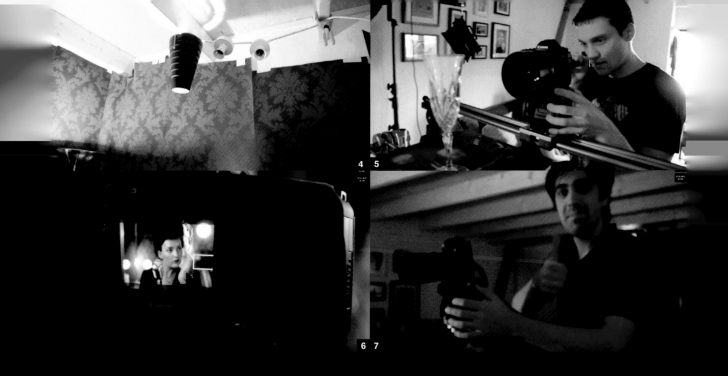

4 5

6 7

…plate over to the starting position and pull it toward you. Practice is important as everyone will find a different way that works for them.

Edmund is brilliant at handheld shots. He used a shoulder-mount rig with the 50mm to achieve "floating"-like footage. He would find a position, set the focus, and then lean back. The shot would remain completely out of focus until he leaned forward to his first position. This creates a dream-like feeling different than what you'd get with a normal focus pull.

What I learned the most from this shoot was the importance of collaboration. Between us we made a video to be proud of, but if you took away just one element, the video would not be the same. No matter how wonderfully you light the video, without a great make-up artist it can only look so good. No matter how beautiful it

looks, without the right music and editing the video would not have been as strong.

HDSLRs are affordable now for most enthusiasts. It is no longer out of people's reach to capture high-quality footage without breaking the bank. But let us not forget that simply pointing and shooting does not make you a filmmaker. Filming is a single element that, when combined with others, creates a great video. To be a good HDSLR filmmaker, you have to take an active interest in all the other elements too.

Credits

Shot by	**James Karinejad & Edmund Curtis**
Editor	**Edmund Curtis**
Vocals	**Emma Michelle**
Make-up	**Nisha Smith**

Camera Settings

Camera:	**Canon 5D MkII**
Lenses:	**50mm 1.2L and 100mm 2.8**
ISO:	**160 and 320**
Shutter:	**30 25fps 1080p**

To see the movie, visit:
http://www.web-linked/vidt/02/

Chapter_ 02

 18

 19

 20

 21

 22

 23

 24

Planning

25 26 27 28 29 30 31

32 33 34 35 36 37 38 39 40 41

18

Identifying your target

1 Fine details will be hard to see on web video.

When planning your project, you need to consider how your target audience will see the video. Viewers have different expectations, not only of image quality but also of duration and placement of graphics in the edit. For example, if your video will appear on a website such as YouTube, you should be conscious that the site places graphical overlays over the lower 15% of the frame. At the other end of the scale, if your project is intended for a cinema screen, then—although at 1080p you certainly have the video quality—you need to consider the audience's expectations of a "filmic" look.

In terms of duration, if you're inviting your audience to sit down and watch a feature film presentation, you should aim for at least an hour. *Titanic* lasted three hours and twelve minutes, though perhaps that was going overboard—Danny Boyle, director of *Slumdog Millionaire*, has spoken of the need to aim for 90 minutes.

Conversely, if you're shooting a promotional piece for a website, it must only be as long as is required to convey the salient points; the longer you run, the more you risk your audience clicking away.

2 At the cinema, detail is easy to see, but viewers can't pause the action while they watch.

19

Crew

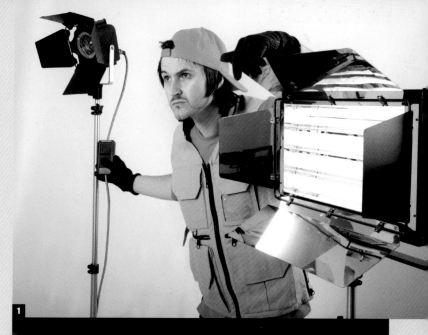

Much of the time, shooting video will involve working with some kind of crew, whether it's just your subject helping out, or a full team including set dresser, sound recordist, and so on, as well as any onscreen talent.

If you're the person who has organized the shoot—if you're acting as director/producer—it's up to you to keep everyone happy. Regardless of whether you are paying everyone else you're working with, having asked or invited them to do so, it's both common courtesy, and very practical in terms of morale and energy, to make sure that food and water is on hand to keep everyone comfortable. In Hollywood shoots, a whole team called "craft services" is devoted to providing on-set catering, and they've even found that there can be a psychological advantage to supplying brand-name products rather than supermarket fare.

Another factor that can slip your mind at the planning stage is bathroom facilities. If you're shooting for an extended period outside the studio, make sure you have made arrangements for this, and speak to the talent, and make-up artists, about their needs too.

Finally, when you've got a crew, there is also a need to communicate. Remember to give everyone notice of the planned shoot well in advance, and arrange a meeting before shooting starts so everyone can get to know each other, and so you can tell them about your vision for the project.

✳ Finding a crew

Aside from family and friends, you can find people in your area keen to gain shooting experience at websites like meetup.com. Also consider local colleges, or more traditional classified sites.

1 Your crew may include lighting technicians, make-up artists, sound recordists, and boom operators, to name just a few.

2–3 For a longer shoot, it might be worth adding some home-cooked food to the standard mix of chips and candy—and don't forget some fruit.

20

Cuts and shots

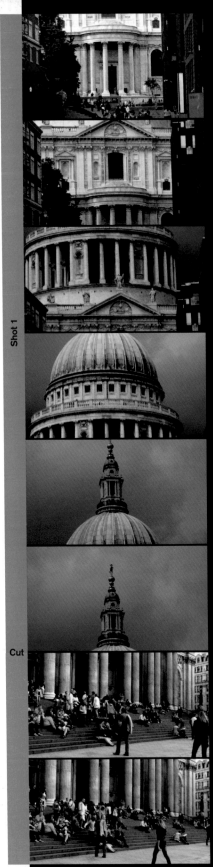

This series of frames shows two shots. The first pans up to the dome of St. Paul's Cathedral in London, and the second shows tourists on the steps. The cut occurs between them.

Shot 1

Cut

There is a language to film, in all its incarnations, and, just like the printed page, it can be broken down into its constituent units. A single frame is like a single letter—meaningless on its own, perhaps, but combined with other frames it builds up to form a coherent whole: the shot.

Typically, a shot's length should be restricted to just the right duration to maintain interest and advance the story—whether that's in an interview, when you might cut between the interviewer and the interviewee, and include shots of both of them in their surroundings, or a narrative scene.

With some video-capable SLRs, there are restrictions on the maximum length of a single shot, either imposed by the camera designers for technical reasons, or simply because the memory cards have a limit (see Tip 11).

There are reasons for creating long, single-shot productions, however. One of the most common is the video tutorial or video lecture, in which a presenter delivers information straight to camera. It's a useful, and quick, way of getting across the kind of details that might normally be delivered in a lecture theatre, but to an audience that might be spread across the world.

In any other production, however, there will be a point where one shot ends and another starts; this is the cut. You can, of course, intercut between two shots in the edit to create a sequence with significantly more apparent "shots." This process is known as cross-cutting.

21

Scenes and sequences

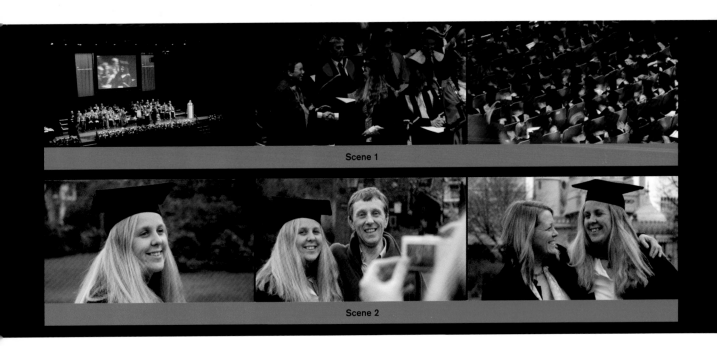

Scene 1

Scene 2

A series of shots cut together forms a scene; to continue the analogy from Tip 20, a scene is like a sentence in a book. It's fair to say that there is no single, precise definition of the length of a scene, but in a narrative piece it generally means a series of shots taken at the same location, of the same event. This can be, and usually is, considerably shorter than a scene in a stage play.

By extension, the sequence is the paragraph, consisting of a number of scenes that advance the story. In a horror movie, for example, a sequence may consist of all of the events that take place between the victim realizing he or she is being stalked by the killer, and the victim's inevitable demise. The individual scenes are the slices of

action that take place in each room along the way: a kitchen fight, hiding behind living room furniture, throwing tools in the utility room, and the attempted flight through the garden at night.

Unlike a basic shot and cut, a scene or a sequence will often end in a transition, like a fade to black, rather than a straight cut to another frame.

The term "sequence" is less familiar to stage directors, but the term "act" still has a place in moviemaking. It is used to describe sequences that build up to form a complete part of the storyline. In a romantic comedy, for example, the first act of the film might be a series of intercut sequences revealing both lead characters in their current lifestyle before the moment they first meet.

This sequence, of a graduation ceremony, has two scenes (in different locations), but runs for little over 20 seconds in total.

22

Fictional projects

Shots, scenes, sequences and acts need to be assembled to make a film—a fundamental difference between filmmaking and stills photography. Rather than attempting to capture a scene in a single shot, there is time for events to play out, which means your project will need a story—a new discipline for most photographers.

Filmmaking, however, is an established art, and the five stages of film creation are well recognized: development, pre-production, production, post-production, and distribution (see box). The last four are covered in more detail later in this book, but before all of that, you need to prepare your story and begin adapting it for the screen.

With some movie projects, you'll begin with a clear idea of where you're headed, especially if you're re-creating a common project type (a to-camera piece, for example), but when you're aiming to adapt a narrative, you will need to begin by breaking it down into filmable components—the scenes and sequences.

It will be both very helpful to you in terms of refining your story, and essential in terms of planning, to create a summary sheet with a list of the characters, and a summary of the story, but without stage direction or dialog. Movie execs would call this a "treatment."

A popular next step these days is a "scriptment," which is by no means set in stone, but is essentially the next stage on from a treatment document, with elements of screenplay included, but limited

The classic stages

These stages can vary greatly depending on what you're shooting, but in the film industry these are the key, distinct steps to making a movie.

* Development: This is the point of adapting your idea for the screen—rewriting a story or researching a documentary, for example. If you are seeking funding for your project, this is the time to do it.

* Pre-production: With a definite plan in mind, you can now firm up exactly what you'll shoot and when.

* Production: This is the shoot itself, in which raw video is captured (the DSLR stage).

* Post-production: Editing and adding any special effects.

* Distribution: When your project is finished, you may want to sell it to a distributor (whether it's a movie distributor or a TV network), or distribute it yourself—perhaps on the internet or via DVD sales.

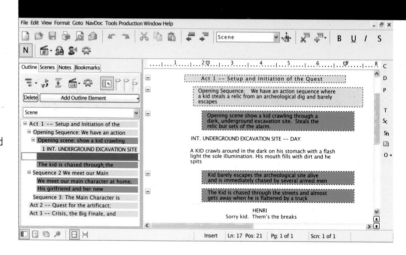

technical details. These are part of a complete screenplay—the next step. A complete screenplay includes clear direction, describing the details of what appears in each scene as well as the dialog.

Dedicated screenplay software, such as Screenwriter, helps writers keep track of the technical details and structure.

23

Documentary projects

Film isn't just used for great (or not-so-great) works of dramatic fiction, on the big and small screen; there are many cases in which you'll want to tell a real story, or simply document events taking place around you. This calls for a different set of skills in the development, pre-production, and production stages, because you won't always be able to anticipate what you'll be shooting.

Good quality classical documentary, however, still has many things in common with the creative endeavour outlined on the opposite page. In the development and pre-production stages, you should consider what the story of your film will be—whose life will we be gaining an insight into? From there, you can work out how to structure the shooting so that we experience what they experience—perhaps the focus of your documentary—as well as have time set aside for interviews.

For example, if your documentary project is about the experience of children at a weight-loss center, you could shoot an interview before, recording the children's expectations, and one after, in which they discuss their feelings about the experience. In the edit, you could use clips from the interviews alongside footage shot during the camp, or choose to use it more chronologically.

The story of a documentary is often enhanced by narration (a device also sometimes used in fiction). When shooting, it is important to remember to include a number of wide or relatively inactive shots that can be used behind the narration, which

would normally be recorded separately and added during the editing process.

But you don't always have to be so sophisticated in your thinking. Having a video-capable DSLR with you at all times gives you the ability to simply find a good viewpoint and shoot video, even when you weren't expecting to do so. All the time the camera is running you are documenting events, and there is always the basis of some kind of documentary, even if you're simply planning to share the events of the day with friends and family.

Documentary projects will run far more smoothly if you do your research and make sure you know every aspect of your story.

24

Storyboarding

For a creative project with even a small team, rather than a solo project, you should spend some time preparing your plan on a shot-by-shot basis. That is the purpose of the storyboard, perhaps the most vital element of the pre-production stage outlined in Tip 22.

If you want your finished movie to be interesting to your viewers, you need to consider the story you are trying to tell and make sure you tell it completely and in a logical fashion. This may not be relevant to all situations, but for a creative short film you are well advised to have a storyboard in place before you start shooting.

Essentially, a storyboard tells the story in still images, often using sequential drawings (much like a comic book) to show camera angles and movements, composition and framing, and even clip durations. You could use photographs instead of, or in addition to drawings, but the overriding aim is to help you crystallize your ideas and start thinking creatively about exactly how you want to convey certain parts of your story. A storyboard doesn't need to be overly complex—a simple collection of images arranged in order is all you need to organize your story so that it creates a coherent narrative.

These frames are a shot-by-shot guide to the planned framing of each shot, as well as any movement of the camera—for example, whether it will follow the subject, or track in on them. While there are some conventions, drawing is not subject to the strictures of the screenplay, and you can always make notes around the drawing to clarify your point. To indicate the camera tracking the subject it's common to simply draw two boxes and an arrow between to show the motion.

For a big project, the storyboard is an important part of the dialogue between the writers, you as camera operator, and the person in charge of the budget—the latter because only when you see the locations that are necessary and the additional equipment you need can you budget effectively. The simple arrow to indicate a moving camera, for example, can require the expense of hiring a dolly.

When you're shooting, your storyboard will act as a guide, helping you to make certain that you cover

1–4 A storyboard by professional film storyboard artist Josh Sheppard.

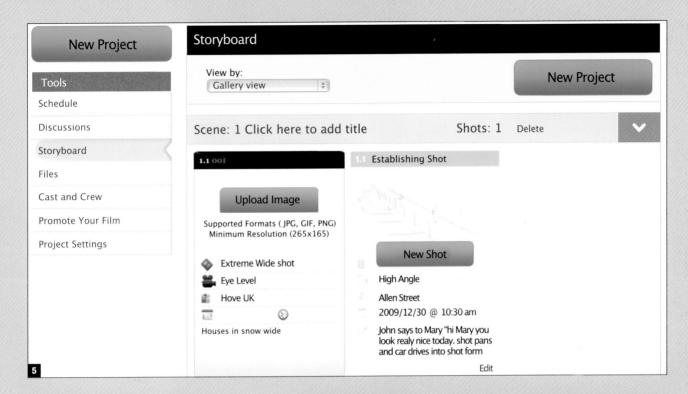

5 As well as computer-based software to create storyboards, there are now web-based systems emerging, like reelclever.com.

everything you want and need to include. That's not to say that your storyboard has to be followed rigidly—if you've got time there's always the opportunity to experiment with a different camera angle or composition that might be useful in the edit—but having it on hand will help you shoot your scenes in a sensible and logical fashion.

A storyboard will also act as a guide when you come to edit your clips together, which will speed up the editing process. If you're working with an editor, rather than doing the editing work yourself, it will also make their job easier, as they will be able to visualize the story you are trying to tell and see how you are trying to do it.

✷ Post-shoot storyboards

Although a pre-planned storyboard is a good starting point for a short film, for some types of video it is not essential. If you are recording a wedding, for example, you will mainly be responding to events that happen beyond your control, so shooting to a storyboard will be almost impossible.

However, while a storyboard may not be particularly important while you shoot, at the editing stage—when you review all the footage you have captured—it may help you decide how to best fit your clips together. You may want to weave in parts of the story out of their natural timeline to create a flashback effect, for example, and it's at this point that drafting out a storyboard can help you structure your footage.

There are many computer programs that will help with storyboarding, both pre- and post-shoot, and if you're an iPhone user, apps such as *Storyboard* from Cinemek can help you generate a storyboard on the move, using images captured with your phone. You can also add camera angles, panning and tracking directions, and a note of how long the clip should last, all of which can be referred to when you reach the editing stage.

25

Framing

There are many different ways of framing your subject, and over time the various options have all been given names to explain what they are, ranging from extreme wide shots to extreme close-ups, with everything in between. The way you frame your movie clips can have a profound effect on the story you are trying to tell, so when you are storyboarding (see Tip 24) you should think carefully about the order and type of shots you want to use.

There are no fixed rules about framing, but there are certain conventions that you need to be aware of. For example, you will often find that a new scene will start with a long shot (see Tip 26), before moving in to a mid-shot (see Tip 27), and then a close-up (see Tip 28), which establishes the scene for the viewer before moving in to reveal more detail. This form of shot progression is typically done by either zooming the lens in, or by moving the camera closer to the subject while keeping the focal length the same.

In either case, the progression is generally made with a series of cuts, not as a continuous shot with the camera running. That's because using the zoom lens to alter the frame of your shot can look a little unnatural, while altering the framing without changing the optics requires moving the camera, which is difficult to achieve without extra equipment.

1–3 These shots are all of the same scene, but framed differently. In the first, the subject forms a tiny part of her surroundings; in the second, we can see more of what she's doing; and in the close-up we see her expression clearly.

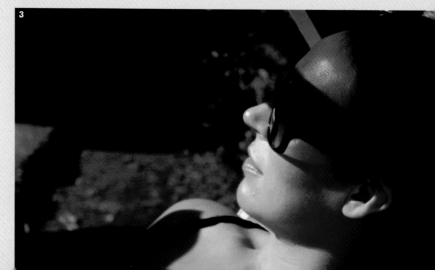

26

Establishing shots

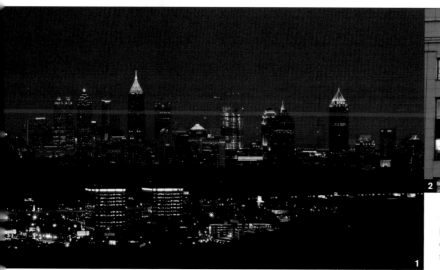

1–2 A wide shot of the Atlanta skyline followed by a second wide shot of office windows. This establishes, in moments, the location of the scene and that it will play out in an office.

3 It's also perfectly legitimate to use close shots to establish a scene.

When you're setting the scene, it is common to start with a "wide" or "long" shot, which paints a picture to your audience of the environment in which upcoming action is to take place. In a soap opera, for example, we'll likely see a shot of the exterior of the venue for the forthcoming drama, for example an office. We might even see one of the protagonists walking into the office, though their full height might only be a small percentage of the frame.

As an addition, it's possible to follow two or three wide shots that sequentially establish the scene with some additional close-ups that, while not directly relevant to any characters we might be about to meet, give the viewer more information about their environment—a few close shots of everyday work taking place in an office, for example.

27

Long and mid-shots

A long or wide shot covers all the action within a scene, and can be used as a way of showing everything that is happening at once. While the definition is by no means strict, if you're including people it should at least be framed so the full length of the person appears in the frame, with space around them to reveal their location. Having space around your subject will also give them the freedom to move around without the risk of "chopping off" their head or feet as they get closer to the edge of the frame.

A mid, or medium shot sits between a long shot (see Tip 26) and a close-up (see Tip 28). When filming a person, it will usually show them from the waist to the head. The aim of a mid-shot is to let the viewer see the subject clearly, so they can pick up facial responses and body language, while at the same time locating them in their environment, so you can see a little of what is going on around them. Because of this, you will find that the majority of your videos will consist mainly of mid-shots, as they provide a happy medium between revealing the environment and showing the subject; they provide some room for the subject to move around the frame, but are close enough to focus the attention of the viewer.

A mid-shot is very useful in documentary-style films in which the aim is to impart information, partly because you can use it to place a lower-third graphic (a name and job title, for example) beneath the subject without it obscuring their facial features, but mostly because we see enough of the subject's body to pick up on their body language. It is important not to underestimate the power of body language; gestures count for a lot.

1 A long shot.

2 A mid-shot.

28

Close-ups

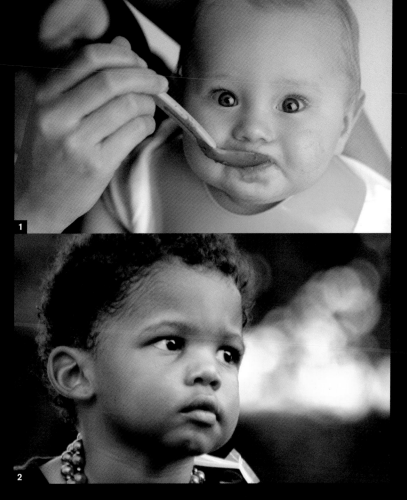

As the name implies, a close-up is a shot that concentrates the viewer's attention on the subject, excluding the background to pick out a detail or show a reaction. You should always try to shoot plenty of close-up detail shots as they can be very useful as cutaways to help break up the pace of a movie or fill a section that may otherwise be too long and dull to watch.

They are also crucial for expressing emotion, especially on television. That's because we understand emotion from tiny movements in people's facial expressions and, especially if we're sitting a long way from the screen, we'll find these harder to see. By positioning the face very large in the frame, we explicitly direct the viewer's concentration toward the emotion involved, at the exclusion of any other detail or distraction.

There are several kinds of close-up, depending on the degree of closeness—medium close-up, close-up, and extreme close-up, for example—and, as with the other shot types, there are no set rules for what precisely constitutes a close-up. However, you should avoid shooting close-ups with wide-angle lenses as the distortion can create unusual effects—a nose appearing unnaturally large on a person's face, for example. Instead, try using focal lengths between 50mm and 200mm to minimize distortion and create a more natural-looking perspective.

1 A medium close-up is framed from the shoulders up.

2 A close-up is framed from the neck up.

3 An extreme close up is framed on the facial features.

29

One-shots and two-shots

1

A different way of describing shots than the one outlined in Tips 26–28 is to consider the number of people you're framing in your shot—typically one or two. A one-shot is usually a medium close-up, leaving room to either hold a lower-third graphic or to reveal a little of what the subject is doing.

A two-shot is a generally accepted term to describe any medium or close shot that frames two people, and its primary purpose is to establish, or continue to show, their interaction.

1 A one-shot concentrating on the subject.

2 A two-shot concentrating on the interaction between two subjects.

30

Over-the-shoulder shots

When you're filming interviews, one of the most common shots you will use is the over-the-shoulder shot, which makes the viewer feel as though they are part of the interview—almost as if they are conducting it themselves. Over-the-shoulder shots should be framed so you see a bit of the shoulder, neck, and head of the interviewer, but with the focus on the interviewee. If you use two cameras, you can film both subjects simultaneously using over-the-shoulder shots, but be careful not to get the other camera in each of the shots!

No matter how many cameras you use, when you are shooting in this style you should make sure that at some points the interviewer's head is nodding at the edge of the frame when you shoot over their shoulder. If you can't see their head move, then cutting to a "noddy" (see Tip 31) will look false. Fortunately, people often nod their heads when listening to someone talking, so you should have no problems. It is worth keeping an eye on, though.

A typical over-the-shoulder shot. This technique is often used to shoot interviews.

31

Cutaways and "noddies"

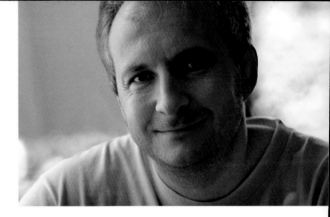

Cutting back to the interviewer listening and nodding is a useful way of making the edited interview more interesting to watch.

If you're shooting a creative movie, you should always make sure you film plenty of cutaway shots. Cutaways are short clips of things other than the main subject that, like close-ups, are used to fill out space, break up longer clips so they are more watchable, or provide more detail to explain something else that is happening. A good example might be a cut to someone wringing their hands in anticipation as the storyline builds up to them receiving some bad news, or a close-up of a book that the subject is currently reading. Having a wide selection of cutaways to choose from will make the editing process much easier and allow you to pad out your footage to make it more interesting to watch. A cutaway can also be used to create a smooth transition between two different shots.

If you're filming a formal interview, "noddy" shots are one of the most important techniques to remember. Effectively, a noddy is a head shot (or head-and-shoulder shot) of either the interviewer or interviewee nodding their head in response to what the other person is saying. They are used to cut into the interview footage to increase the illusion of two people having a conversation in real time.

The easiest way to film noddies is to shoot with three cameras—while one records the interview, the other two are set up to record noddy shots of the participants. However, you can still shoot noddies with just one camera. Shoot the entire interview, concentrating on the interviewee, and then do another take to capture the noddy shots of the interviewer. These can be dropped into the footage at appropriate times when you are editing, to give the impression that the interviewer is paying attention. Remember, there is no need to capture any sound when you're shooting your noddies, as the audio track will be of the interviewee continuing to talk while we see the interviewer responding.

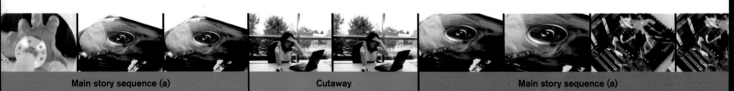

| Main story sequence (a) | | | Cutaway | | Main story sequence (a) | | |

A sequence of a disaster in the IT department features a cutaway to a woman at her desk, experiencing the problem.

32

B-roll

1

There is some debate over the origin of the "B" in the term "B-roll"—whether it harks back to the days of 16mm film or to the second of a TV editor's twin tape decks—but in the digital age, that need not concern us. B-roll is simply the supplementary material you can add while editing your movie, to introduce additional context.

Making sure you set aside a bit of time to capture some B-roll when you're shooting will make life immeasurably easier in the edit, as there will inevitably be occasions when you want to introduce a cut into a longer shot without, for example, interrupting the flow of the audio. Similarly, what you might think of as extraneous material as you shoot could easily become the only establishing shots that you've got on your memory card.

Incidentally, it's worth noting that many filmmakers, especially documentary filmmakers, would be offended by the suggestion that any of their footage is B-roll. That's a sensible way to look at it; the additional footage is an equally important part of describing the scene you're shooting or the story you're telling. You're getting a different kind of footage than you do by pointing the camera directly at your subject and asking them to act or answer questions, but by showing their context you're extending the story.

1 A classic B-roll shot that could be cut into the movie between developments to remind the viewer of the settings and perhaps the shift to evening light.

❋ B-roll ideas

Of course, this depends greatly on what you're shooting, but here are some ideas to consider when shooting extra material.

❋ If you're shooting an interview, try to get some shots of the building or location. Was there an entrance lobby? Perhaps shoot additional scenes of your interviewee arriving and leaving (or at least pulling up).

❋ In any situation, try to shoot some additional angles of the location in which the action or events take place.

❋ Before moving the camera from a position you've used extensively, aim to capture a few moments of video without any people in the shot; these can often be useful in post-production.

❋ Wherever you're shooting, make sure you've got some generic shots of the location, whether it's some ground-level city shots or a pan across a site of historical interest. If you decide to add a title sequence later, these might come in very useful.

33

Continuity

When you edit a movie—no matter how long or short it is—the whole film should look as if it has been shot across a continuous timeline. In other words, nothing should change between shots. As an example, if your subject is drinking a glass of water in one shot, and it's nearly empty, it shouldn't be full in the next shot: if it was, it would imply you'd stepped back in time.

Some subjects are naturally going to be continuous in their timeline—filming a wedding or a soccer match, for example. These situations have a defined timeline that you cannot change—the bride can't suddenly be unmarried after the vows and a touchdown or goal cannot suddenly become unscored. However, in creative moviemaking, where there is no continuous timeline in place, you need to pay attention to the details—if you don't, your audience may notice the break in continuity and their immersion in the action will be disrupted.

On a professional movie set there are two competing theories about continuity. Directors will often favor "emotional continuity" over "physical continuity," so ensuring that actors' expressions are consistent is more important to them than a small, seemingly inconsequential detail such as a glass being full or empty. On the other side are the continuity checkers, whose job is to make sure everything is consistent, and who will argue that everything should be just so.

In many cases—especially if the movie is engaging enough—viewers are unlikely to notice minor continuity errors, but you should still keep a watchful eye for obvious differences between shots, as having both physical and emotional continuity will result in a better movie. One way in which you can do this is to use a compact digital camera to capture a still of the set before shooting. This can be printed out on a compact printer (or viewed on a laptop) and used to check that objects haven't moved between takes.

1–2 Exactly the sort of problem that can cause a breach of continuity. Whether it's evaporation or simply your talent taking a gulp, the jump between shots (even if it is just a minor detail) is an issue.

34

Line of action

The line of action, or continuity of movement, is a principle of filmmaking designed to help avoid confusing the viewer, and to make scenes involving travel easier to shoot and edit.

It stems from the fact that we subconsciously perceive ourselves as existing at a point in relation to the action and, once that action has started, we really don't want to be moved unnecessarily. A common example is televised sports: in a football game, the main camera is positioned on one side of the field and follows proceedings from that vantage point. All the other cameras are placed on the same side of the field, and if they really want to show you a moment from elsewhere—usually a replay—they'll clearly mark the shot "reverse angle".

Most movie action sequences work in the same way, though in between shots from the director's chosen side you will frequently see either close-up shots of the hero's struggle or point-of-view (POV) shots showing us the hero's view, either as a direct POV or with over-the-shoulder framing.

The same is true of a dialogue scene between two protagonists. In this case the principle is more commonly referred to as the 360-degree rule, and the principle is that all your camera positions should be within the semicircle on one side of the apparent conversation.

1 In a sequence showing the transit of goods, the line of action requires the different carriers to be traveling in the same direction.

2 The green arc represents the 180-degree area within which it is safe to place the camera. Placing it in the red area would cause the protagonists to swap sides and confuse the viewer.

35

Eyelines

One of many principles to consider when shooting is how you lead your audience through the story, from one shot to the next. Establishing shots (see Tip 26) are a useful method for setting almost any scene, but—especially for dramatic reasons— you may not always want the audience to settle in, or you may prefer to include a narrative element rather than a change in view.

A classic solution is to follow an onscreen character's eyeline. In its simplest form, this may involve showing a close-up shot of a character changing their angle of view or turning their head, and immediately following it by cutting to the object or person that is the apparent focus of their attention. For emphasis or drama the viewer might have binoculars or a telescope, and of course the shot can be held on the subject for some time, to show their reaction, before revealing the subject of the character's interest to the audience with the cut.

An extension of this principle is the "eyeline match," in which the second character looks back at the first while the camera is on them, acknowledging their presence and potentially moving the story on at the same time—because now, from these reactions, we as an audience can judge how the characters feel about each other.

1–2 In a simple eyeline shot, we see a character looking at something, then immediately cut to what the character sees.

3–4 The movement of a person's eyes is hugely significant to the audience's feeling of interaction.

36

Angle of shot

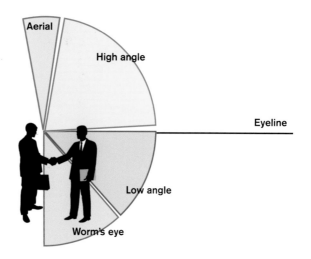

Aerial

High angle

Eyeline

Low angle

Worm's eye

Tips 25–28 cover the possibilities of framing a shot differently to include or exclude details, and the way that these shots can be added in sequence to tell a story. The other aspect of composing your shot is the angle you adopt—whether you choose to shoot your subject from a point level with their eyes, to look down on your subject, or look up, at them, can significantly alter the atmosphere of the shot.

If you're shooting children at play, for example, there's a lot to be said for getting down to their level and "entering their world," rather than remaining aloof. Indeed, in most contexts, looking down on your subjects creates an air of detachment.

In a dramatic production, you might shoot from a slightly lower angle, looking up at a significant character to emphasize their power or the threat they represent. However, if you place the camera right on the ground, looking up at a person, the result may be more comical; this shot is known as the "worm's eye" view.

If you're shooting for a factual project, it's worth noting that many commentators consider anything other than eyeline shots to be distorting the truth of your work, so you should consider your intentions. This is convention only, of course, and there may be many reasons to deviate from it, but at least when setting up interviews it's worth bearing in mind.

In this shot of two children playing, the camera has been lowered so that we, the audience, feel like we're on the same level as them, and joining in the fun.

37

The impact of color

The blue evening light in this shot adds a cold feeling, even though it was actually warm at the time.

The technology to record color is now a given, so there's no need to go over the impact that "living color" introduced. With the advent of the HD standards used in modern digital cameras, there is also no longer any need to worry about colors bleeding or changing (a common problem with American TVs for many years).

Color brings with it important psychological factors that are not always fully understood, especially when you are "merely" documenting events around you. If you're taking the time to carefully plan a production, however, you'll be thinking about locations, costume, props, and lighting, all of which introduce color to the screen. Given that, you would do well to be aware of both the simple balance of the colors—do they work well together—and the dramatic impact.

Shades of blue, for example, can appear cold, both physically and emotionally, while red is seen as symbolizing power and aggression, as well as romance. Yellow and orange have connotations of warmth.

If you are planning on making use of the symbology of color in your movie, you'll also need to take your target market into account; white is associated with mourning in the east, but not in the west, for example.

✷ Color symbology

Some examples of symbology associated with colors.

BLACK
Power, fear, evil, depth, mystery, hiding, mourning, death.

WHITE
Marriage, purity, birth, innocence, winter, sterility.

RED
Energy, passion, heat, blood and vitality, joy, intensity, threat, dynamism (and, at the pinker end of the spectrum, love and romance), visibility, fun.

ORANGE
Energy, warning or other need for attention, vibrancy, fire, coziness, Halloween.

YELLOW
Joy, cheeriness, sun (and associated new birth, etc.), cowardice, illness, creativity. It is also seen as lightweight.

GREEN
Growth, renewal, luck, "the green-eyed monster," natural, patient, outdoor adventures, athleticism, balance, and safe.

BLUE
Water, calmness, cold, conservatism, security, deep, free, educated, lonely, clean, authoritative, formal.

PURPLE
Royalty, mystery, arrogance, art, distant, luxury, vanity, fantasy, solemn.

38

Time

Manipulating time is essential to telling your story on screen. Have you ever noticed that when you're watching an action sequence in a movie, some events seem to take much longer than they would in real life? That's not an accident of editing, it's a principle called subjective time, in which the editor deliberately uses extra shots to extend the apparent time in which events are taking place, so the audience can understand all the emotion the central character is experiencing.

That said, over the course of the whole movie, many days' or even years' events are distilled into a few minutes. How can you plan your script and shot list to overcome this apparent dichotomy? The answer is that, in fact, your audience is surprisingly forgiving. Film editing has been described as "cutting out the boring bits," so in assembling your script and planning your scenes, you should concentrate on points of dramatic significance, followed by individual key moments of emotion.

You won't be surprised that the advertising industry has studied this phenomenon too, having discovered a statistical link between ads that "seemed to go by fast" and interest in the product being advertised.

Incidentally, if you have an interest in seeing a film created in clock—rather than subjective—time, Andy Warhol's movie *Sleep* is a significantly more serious attempt at this feat than TV's 24.

In terms of the overall production, linear time is by no means compulsory in scriptwriting, and—so

long as it works—audiences will not be upset by rearranging the sequence of events, as Quentin Tarantino does in *Pulp Fiction*. You'll notice, however, that this doesn't happen on a shot-by-shot basis, which would be completely disorientating. Instead, a series of discrete sequences are edited, and inserted almost as explanatory notes when the overall plot calls for them.

Finally, in film you have the option to manipulate physical time, by speeding up or slowing down events ("slow-mo"). This is a great way to clarify and accentuate moments of action, but obviously breaks any sense of realism.

39

Subjective and objective treatments

2

As filmmakers there are two ways to address your audience; you can either sit them on the side, watching events, in a traditional objective treatment, or place them inside the action, with a subjective treatment. These are not mutually exclusive; a complete project can feature shots of both kinds.

A classical objective shot is one in which the camera remains completely still while the subject gets on with whatever they're doing, be that some kind of action or interaction.

A shot becomes subjective when the viewer is treated as a participant, as with a point-of-view shot in a car chase, when we're introduced to the experience of fast movement. To be truly subjective, a shot can show us not just what the character sees, but how—a dream sequence or the special view the Terminator sees with data feedback.

This principle can be extended to the point that we "break the fourth wall" and the viewer is addressed directly—for example, if a character looks straight at the camera lens and acknowledges the presence of the audience, a device used frequently in modern comedies. The fourth wall in question is traditionally the one that doesn't exist on the stage or in a studio because it is occupied by the audience, cameras, or both.

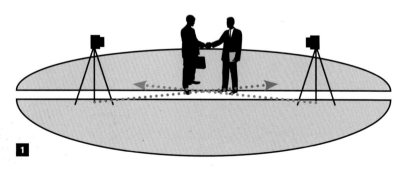

1

1 Both camera positions in this diagram afford the opportunity to shoot "subjective" shots of the conversation, giving a view broadly equivalent to that seen by the subjects.

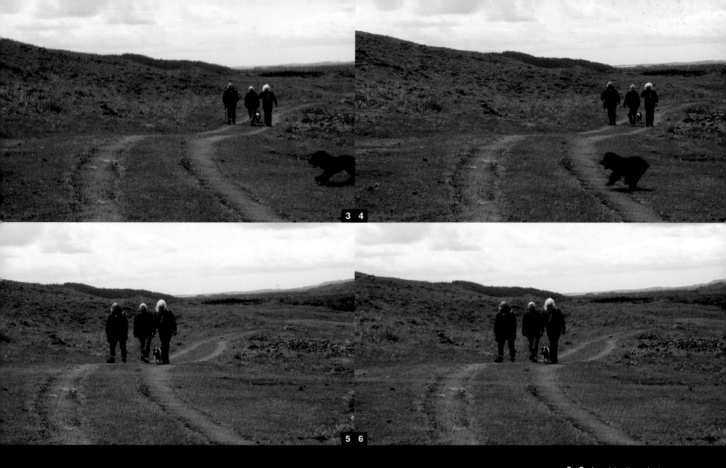

3 4

5 6

2–6 An objective shot, taken from a single point as the subject moves within the frame, and eventually walks out of it.

7 8

9

10 11

7–11 This shot has an element of objectivity because the camera is mounted to the boat, which remains still as the surroundings rock up and down and move.

40

Foley sound

Recording the sound of
a coffee mug being placed
down on the table.

Foley sounds are sound effects—hands clapping or a cup being placed on a saucer, for example—that are hard to record while shooting, but are required in the finished movie to add depth, atmosphere, and realism. For DSLR video, your foley sounds will most likely consist of sounds that are recorded separately using a sound recorder, so they can be added to the soundtrack during post-production. While you don't need to do this for every sound effect (and in many cases you won't need to do it at all), you may find that recording a foley sound is the best way to get a clean audio track, as you can control the levels of each sound independently.

If you don't have a separate recording device, you may have access to a laptop, and most of these include microphone sockets. On some machines you might need to make a change in the settings panel so a mixed-use line-in/mic socket is in the correct mode. If you only have your camera but file storage isn't a problem, you can simply shoot video and record sound at the same time, remembering to only use the sound in post-production (especially if you've got the microphone in shot).

To collect your foley sound, make sure there are no other environmental sounds around when you are recording and place your microphone as close to the source of the sound as possible. Be sure to name all of your foley sounds accurately when you import them to the computer—simply labeling them Foley 1, Foley 2, Foley 3, and so on, will cause nothing but confusion when you come to try and add them to your soundtrack.

41

Background music

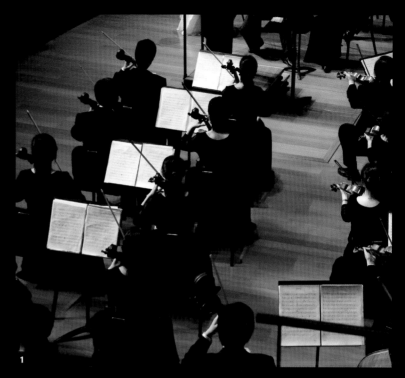

1

2

The next time you watch a movie, pay close attention to the soundtrack, as it is often more complex than you would first assume. In addition to active sound, B-roll audio, and foley sound, you will also hear one of the most important parts of a movie's soundtrack—background music. The music in a movie can, almost more than any other aspect, set the tone of a scene: creepy, scary music will heighten the feeling of terror in a scene, while happy, bouncy music makes it much lighter.

As a photographer, it's likely that you won't pay much attention to the sound in your movies, but you should. Although you'll probably have captured voices and ambient sounds, you should also spend time thinking about background music. However, you need to be very careful where you get this music from, especially if you intend to distribute your work to a wider audience via the internet. Just as you own the copyright on your movies and photographs, so most music is "owned" by someone else and should not be used without permission. Therefore, you need to either seek permission from the copyright holder, pay someone to compose and perform music for you, or locate some royalty-free music. There are a variety of websites where you can find royalty-free music, and it can cost as little as a few dollars per song—a lot less than going to court for breaching someone else's copyright!

1 Agencies exist that can write music especially for you, or find appropriate royalty-free material.

2 Audio tracks fading in and out in a track-based editing program.

Commercial / Clive & Rob Streeter

Between us we've been shooting professionally for around 20 years, specializing mainly in food and portrait work. We started way back when film was the only option available, and Polaroid the only way to check your shot before exposure. In the last few years we've seen huge changes to the way the image is captured and dealt with, and to the expectations of the client, with digital technology as the main catalyst.

It became clear in the last year or so that many clients would need moving image content alongside their stills requirements to "keep up" online. We made up our minds to begin shooting a video showreel, with the aim of providing both moving and still images to existing and future clients.

Happily this decision coincided with the release of the new generation of HDSLR cameras, able to deliver stunning high-definition video through top-quality lenses. As well as outstanding image quality, the cost and relative simplicity of these cameras meant that it was feasible to shoot high-end footage for the lower budgets commanded by web video. We soon found

that the cameras coped just as well for broadcast and even cinema projection!

The project we are discussing here was a short television commercial for a food client. It was an interesting challenge as the cameras we intended to use, the Canon EOS 5D MkII and EOS 7D, had only been used for a couple of broadcast projects at the time, and were not widely known about by the agencies and production companies. We needed to be sure that our plan was watertight and there would be no unwelcome surprises when the client arrived.

We were provided with a short script of the voiceover, and a sketch of the endframe. This gave us the primary information we needed for shot duration and composition. We also had some initial art direction from the agency to help us understand the look and feel we would have to create. The shot was to be a gentle ease in on a bowl of strawberries lit by a gentle summer light. A hand would then come into shot and pour cream on top, then place the cream down again and withdraw. The timings were crucial, as a voiceover had to correspond to the action on screen.

First, we planned the lighting. The scene would need a soft general fill, with a "dappled" effect cast across the background to evoke a summer mood. The food would also have to look fantastic. For the strawberries we prepared some small reflector boards and a smaller light to give them a slight shine. We experimented before the shoot day to determine the best setup, but it was the camera that threw up the two main challenges.

The camera move had to be planned. We had two options:

1. Use a dolly to track in on the action gently and direct the hand model while watching the monitor.

2. Keep the shot a little wider and track in digitally in post-production.

The first option would be the most technically demanding. We had a little experience with the camera dolly in question, the P+S Technik Skater dolly, but getting the timings right under pressure would be tough, and with the voiceover yet to be finalized there was a lot of room for error.

The second option would be more straightforward but depended on how far the client needed to zoom in digitally.

Zooming in too far would degrade the image and spoil the look. With not much time to experiment before the shoot, we rented the dolly and held back the post-production option as a safety net.

The second challenge lay in the frame-rate choice. Spend any time at all looking at food commercials and you will soon notice the amount of slow-motion footage used. Part of the appeal of the images is that you have

Using the editing software we have in the studio, we previewed what the finished shot would look like to the client on the day, to set their—and our—minds at rest.

Having complete control of the zoom in post enabled the editor to match the shot to voiceover perfectly. This method is a great example of overcoming the limitation of HDSLR shooting using editing software—the cameras are so light that

a victory for the HDLSR technology, which enabled a shoot that would usually have required a crew of people to be completed by a two-man team. It's a formula that we have since repeated on a number of different projects, and we are constantly looking at new equipment and software solutions.

time to see the ingredients move luxuriously in front of the camera. This requires the footage to be filmed at a high frame rate so it can be slowed in post-production.

For the HDSLR shooter, the options are quite limited. The EOS 5D MkII has the bigger sensor and gives video resolution of 1920 x 1080, but shoots at 25fps. It's hard to slow 25fps down in post-production without the image staggering a little, and it won't look like that smooth-moving commercial you're used to seeing. The 7D can capture at 50fps but does so at a smaller video resolution of 1280 x 720. 50fps can be conformed to 25fps, giving you half speed—not "slow motion" but enough to give us the look we needed.

We phoned the post-production house that would be dealing with the footage and sought their advice. They had only dealt with one other HDLSR shoot so far, but between their experience and ours we agreed that the best option would be to shoot at 50fps so that the pouring could be slowed down, as 1280 x 720 should still be ample resolution for the standard-definition broadcast. We shot a couple on the 5D to make sure we had a backup plan, however.

special equipment is needed to move them without camera shake.

The cost of hiring the dolly, even without an experienced operator, is such that it would have taken a lot of profit out of the job. Thanks to the digital "ease in" available we found a way around this costly problem.

With the shoot over, we attended the grading at a post-production company where the footage was assessed and color graded. There are strict rules governing footage for broadcast that ensure consistent high quality, so it was at this stage that our preparation would really be put to the test.

The camera's color reproduction was fantastic and needed very little work. The exposure was also accurate and proved that the camera's histograms were correct (see Tip 45 on setting exposure).

It had been hard to be completely certain on our 9-inch monitor, but the hand model had done a great job, and even on large viewing screens the action was smooth and natural.

Overall, the result was satisfying and the client was very happy. It was also

Full equipment and crew list

Kit
1 x Canon EOS 7D
1 x Canon EOS 5D MkII
1 x Canon 100mm $f/2.8$
1 x Canon 50mm $f/1.4$
1 x Red Rock Micro Rails and
 Matte Box
1 x Sony 9-inch Monitor
1 x Zacuto "Z Finder"
1 x P+S Technik Skater Dolly
1 x MacBook Pro and card reader

Crew
2 x Photographers
1 x Home Economist
 (food preparation)
1 x Hand model
1 x Assistant

Chapter_

 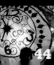

Shooting

42

Orientation

When it comes to shooting movies, you need to be aware of the medium on which they will be displayed. With very few exceptions this will be a computer monitor, television screen, or (if you have a big budget and produce something amazing) a cinema screen. The one thing all these have in common is their orientation: they are all horizontal or "landscape" format.

That's not to say you can only shoot movies in a horizontal format, and there are situations in which a vertical format can actually work better—if you want two or more vertical clips to be shown simultaneously on screen, for example, or you are specifically shooting a movie for display on a vertically mounted screen (some advertising jobs might specify this). The general rule, though, is to avoid vertical movies, so if you're combining shooting stills with HD video, remember which mode you are in to prevent any accidents.

Also, depending on your camera model, it's possible that there will be a dramatic reduction in image quality when you shoot in portrait format. That's because the camera's orientation sensor—which it uses to rotate images when you're shooting stills—is used in video too, and the camera will rotate and shrink the video so it still appears the correct way up in the center of the traditional horizontal movie, with large black areas to either side.

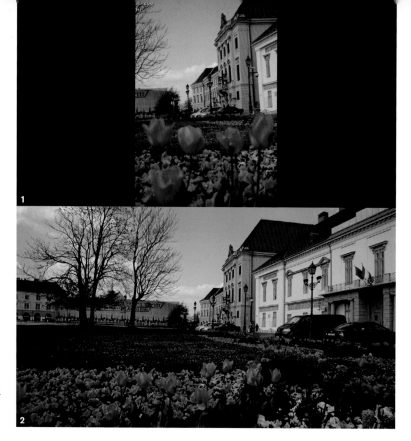

1–2 You can't display a portrait image without wide black bars occupying over half of the screen area, so it's better to recompose the shot, or pan up.

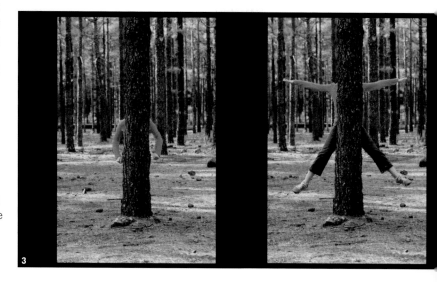

3 The exception to the rule is unusual video effects such as multiple views on a singe screen, all of which need careful planning and post-production.

43

Shooting stills during movies

Most video DSLRs give you the option to capture a still image while you're shooting a movie. This is not likely to be very useful to you most of the time, but on occasion it may just help you to obtain a still image that can be used to tie together the parts of the story you're trying to tell.

When you shoot a still during filming, you don't actually get a still and a continuous movie scene at the same time, as the sensor can't capture two sets of data at once. Instead, taking a still will pause the movie momentarily, capture the still photograph, and then continue recording the movie footage. Depending on the camera and your settings, this will give you a Raw and/or JPEG file, plus a movie clip that will pause for a moment when it's played back. The pause can be edited out, of course, but if you want to shoot a still frame mid-movie, it's a good idea to keep your camera's orientation in mind (see Tip 42), because rotating the camera will mean a longer pause while you take your photograph.

While it is possible to shoot stills during filming in movie mode, in practice you should try to stick to one or the other. The two disciplines are quite different and trying to do both at once can easily result in confusion and both poor images and a poor movie. Concentrating on one at a time is much more likely to yield better results.

This sequence shows what would happen if you take a still while filming; some moments would be missed.

Clip 1

Nothing recorded

Still

Nothing recorded

Clip 2

44

Shoot more

1–4 During the course of the event—which will be edited into a series of very brief shots—a number of following pans and other shots are taken, which can be trimmed in the edit.

Whatever you're filming, always shoot more than you think you'll need. If you get the opportunity to have several attempts, or "takes" at a shot, make the most of it so you can be sure you end up with one that's good. You may find that two clips which appeared to be the same when you shot them look quite different when you come to edit them together. Maybe your subject looks more natural in one than the other, or perhaps you focused a little more accurately. It can even be something as simple as a small amount of camera shake in one take that's not present in another. Regardless of the reason, you'll be surprised how much footage is discarded and ends up on the "cutting room floor," never to make it into the final movie.

It's not just the number of clips you should film, either—the length of the clips should also be longer than you think you need. If you are filming a scene that you have control over, start recording and wait a few seconds before giving the "action" signal. And when you think you have shot enough, don't stop

immediately—keep the camera rolling for a few more seconds, just to be sure. After all, you're not burning film, only space on your memory card.

If you're filming something beyond your control, then the same principles apply, but you need to try to anticipate when to start the camera rolling before the action happens and continue shooting for a few seconds after it's stopped. Having this extra footage at the start and end of your clips will make it much easier at the editing stage because you'll have space either side of the action that allows you to decide exactly where to cut.

However, when it comes to editing, don't just cut the clip and trash the beginning and/or end. Instead, make use of in and out points to trim the clip, while retaining the footage either side. This will allow you to use the ripple and roll tools to fine-tune the clip so it better fits the flow of the action, the background music, or both.

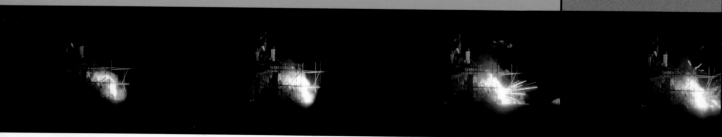

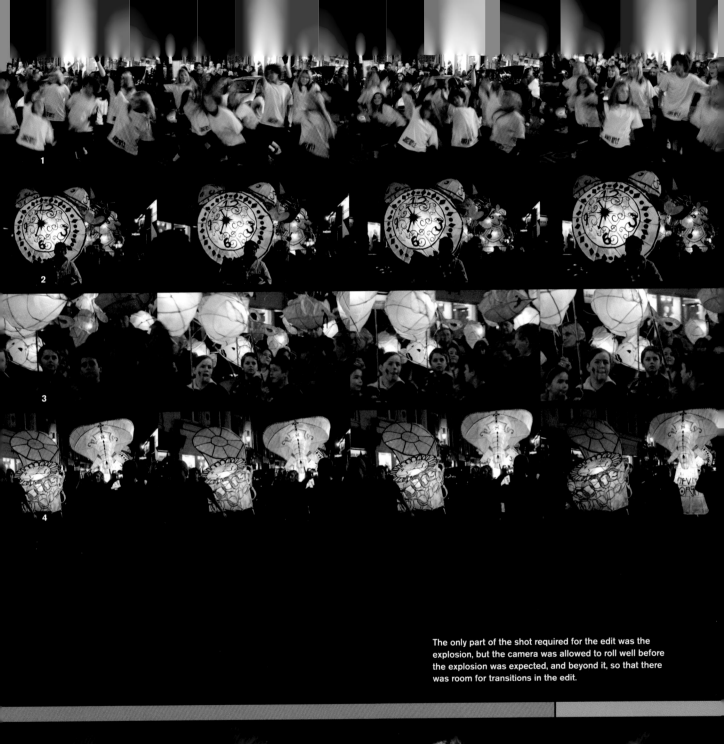

The only part of the shot required for the edit was the explosion, but the camera was allowed to roll well before the explosion was expected, and beyond it, so that there was room for transitions in the edit.

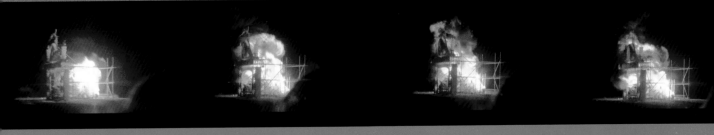

45

Exposure settings

> ✳ **Signal-to-noise ratio**
>
> To maximize your signal-to-noise ratio (i.e. to minimize noise and produce the best-quality images), you should set your exposure to be as bright as possible without overexposing any highlights.
>
> However, while this will give you the most amount of detail in your footage, it will also necessitate exposure adjustments in post-processing, which can be a long and complex process. For that reason, it is often better to pay less attention to your signal-to-noise ratio and just aim for the correct exposure.

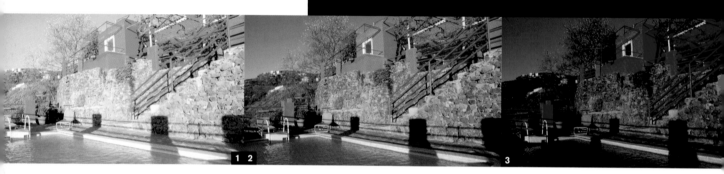

As with shooting stills, there are primarily two ways that you can set the exposure on a DSLR movie: either by letting the camera do it for you automatically, or by taking control and setting it manually. Even if you are just starting out in video, you will quickly realize the limitations of relying on the camera's automatic exposure setting, for no other reason than the lack of control it gives you over the shutter speed (see Tip 47).

This makes setting the exposure manually slightly more important, and some video DSLRs provide the equivalent of shutter-priority and aperture-priority modes. If you're not worried about the aperture (and depth of field) changing, you may find shutter-priority mode is useful as you can lock the shutter speed depending on the look you want and let the camera set the appropriate aperture. Alternatively, if you want precise control over the depth of field, aperture-priority mode will allow you to achieve this, with the camera determining the shutter speed.

However, you need to avoid the exposure changing while you shoot—and when you use auto,

aperture-priority, or shutter-priority mode, this can be unavoidable. If your subject moves from a sunlit area to a shaded one, for example, the camera will try to adjust the exposure to compensate, and as the exposure adjustment is made in steps, the automatic adjustment will look obvious and unnatural.

To overcome this, you can set your exposure manually. Although this may seem daunting, it is actually quite straightforward, because you can judge your exposure at the same time as you view the composition and focus on your DSLR's rear LCD screen: simply adjust the shutter speed, aperture, and ISO until you achieve the look you want. The only difficulty is that the LCD can be affected by ambient light levels, so it is not completely accurate. This is where an LCD screen loupe (see Tip 51) can be very useful, as can an understanding of your camera's histogram.

1–3 Overexposed by one stop, correctly exposed, and underexposed by one stop.

46

Understanding histograms

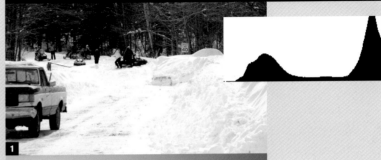

✱ Let the histogram guide you

On some video DSLRs, it's possible to see a live histogram when you are shooting in movie mode. This can help you set the exposure correctly and see whether any shadow or highlight areas will be clipped.

If there is one tool that can tell you whether or not your exposure is correct, it's the histogram. On most video-enabled DSLRs you can see a live histogram before you start shooting any footage, but this is of no use if you don't know what it is telling you.

A histogram is basically a bar chart with an X-axis and Y-axis. The X-axis, running horizontally along the bottom, corresponds to brightness, from pure white at the right to pure black at the left. The Y-axis, running vertically, indicates the number of pixels containing that particular level of brightness. The key thing to remember is that the height of the bar doesn't matter (it's irrelevant if one pixel is a certain tone, or 20 pixels are that tone) and you should only be worried about the extreme left and right edges. If you have bars at either end, then it shows you will have blocked-up shadows or blown highlights in your footage. This is known as "clipping" and should be avoided whenever possible.

A common misconception is that there is an "ideal" histogram that is bell-shaped—rising from the left edge, upward toward the center, and then down again to the right. This is simply not true. Unless you are filming (or photographing) a subject that consists of a lot of midtone gray, with gradually decreasing numbers of highlight and shadow pixels, you will never see this. Ultimately, the ideal histogram is one that shows you have captured all the detail in the scene without blocking up shadows or blowing highlights, but in reality the scene you are filming will determine what the histogram looks like.

If you are filming a scene that is predominantly bright, your histogram will be bunched over to the right side, but if your scene is mostly dark, your histogram will shift to the left.

If your camera doesn't give you a live histogram before you start filming, then a quick way of checking your exposure is to take a still image and check the histogram on the playback screen. This will show you if you are overexposing or underexposing the scene and whether you need to make any adjustments before you shoot for real.

1 In a snowy scene, the histogram will be bunched toward the right, the highlights end.

2 In a dark scene, the histogram will show a large area at the left, shadows end.

3 An evenly balanced histogram suggests the images has tones across the range.

47

Shutter speed

2–3 A shutter speed of around 1/30th second blurs the background as the camera pans with the speeding cars.

1 A shutter speed of around 1/1250th second brings out sharp spots of falling water in this shot.

4 A shutter speed of 1/30th second is used here too.

✳ Flickering

If you are using artificial lights to illuminate a scene, you need to be aware that certain shutter speeds can result in a flickering image due to the frequency of the light. If you notice this, try an alternative shutter speed—you should be able to see the difference on the rear LCD panel.

The shutter speed you choose to shoot your movie at will be dependent on the look that you are trying to create. On the majority of DSLR cameras you can select a shutter speed range of 1/30 sec to 1/4000 sec when you are shooting video, but while this appears to give you a wide range of shutter speeds to work with, the reality is you will probably only be working at the slower end of this scale.

In still photography, shutter speed has an obvious effect on the results you get when you're shooting moving subjects, and the same applies to video. But although you can select very fast shutter speeds, don't think that you always need to use them with moving subjects. In fact, you will find that better results will be obtained at slower shutter speeds because although each frame will be blurred slightly more, when they are played as a movie clip it will produce the illusion of smoother motion.

If your camera has user-selectable frame rates, the slowest shutter speed you can use will be limited by the frame rate you choose to shoot with. Generally, most people want to recreate the "cine" look (see Tip 05) and, to do this, you should select a shutter speed that is as close to double your frame rate as possible. So, if you are shooting at 24fps (for the cine look) you would choose a shutter speed of 1/50 sec, while if you were shooting at 30fps you would select a shutter speed of 1/60 sec instead. That's not to say that you can't use faster shutter speeds, and these can be used creatively to "freeze" motion in a scene—small objects in the air after an explosion, or spray in waves crashing against the beach, for example. Obviously they won't be totally frozen as they would in a still image, but in your video you would see these bits of debris more clearly if you used a faster shutter speed.

3

48

Rolling shutter

1

2

Rolling shutter effects are created as the shutter inside the camera moves across the frame during an exposure. Many DSLR cameras use a CMOS sensor, but when this is used to record movies, the light falling on the sensor is not read as a whole. Instead, each line of pixels on the sensor is read one after the other in sequence. With fast-moving subjects, or when you're panning quickly, straight edges may take on a curved or even diagonal appearance, ranging from a skewed image to a wobble commonly referred to as the "jello effect." Avoiding both of these things will help, as will using a stable tripod (see Tip 53), as rolling shutter is most evident when the camera is handheld.

This isn't something you're likely to be able to escape easily, as CMOS has become the favorite sensor chip of the industry. Unlike the alternative CCD system, a CMOS chip can be designed to handle additional processing tasks, which reduces costs and weight in camera design. In fact, many consumer camcorders are now fitted with CMOS sensors precisely because of the added flexibility these chips offer.

You can't avoid the rolling shutter effect entirely if you are using a camera with a CMOS sensor (although some cameras are less susceptible than others), but there are ways that you can minimize it. Ask yourself, "Do I need to pan this quickly?" In most cases, a fast pan will be difficult for the audience to follow anyway, so try making the turn more slowly. If you do need to pan quickly—perhaps to follow a moving subject—consider widening the aperture so that any sharp vertical lines in the background are softened. Rolling shutter is only really a problem when it is visible, and it is most visible on vertical lines in sharp focus. If the audience has something else to concentrate on, and if the effect is minimized, you have little to worry about.

1–4 Panning the camera across a Venetian blind reveals the effect: horizontal lines are unaffected but the verticals lean.

3

4

The only way to avoid rolling shutter entirely is to use a camera that is fitted with a CCD sensor. This is because a CCD uses a "global shutter," in which the entire sensor is exposed at once (in much the same way as a still photograph)—that's why many video-specific cameras use CCD chips rather than CMOS sensors. However, at the time of writing, there are no DSLRs available with CCD sensors and a video mode, and for the reasons stated this seems unlikely to change. The only cameras with CCDs are medium-format digital backs, which are produced to a different component cost model.

✳ Tactics for avoiding rolling shutter

Depending on what you're shooting and the equipment you have available, there are a number of different tactics you can adopt.

✳ In a multi-camera production, use a CCD-based camcorder for panning shots. Your DSLR is perfect for the artistic shots, but panning shots involve movement, so the camcorder might be a better choice.

✳ When you're only shooting with one camera, consider tactics for reducing the number of panning shots, or using a slower shutter speed in order to soften the effect.

✳ Use a software tool in the edit which can compensate for the effect of the rolling shutter. Possibilities include RollingShutter, an After Effects plugin from thefoundry.co.uk, or Lock and Load X for Final Cut Pro.

✳ Avoid rapidly changing lights, as this can lead to partially exposed frames.

49

Aperture

As with stills photography, the aperture regulates how much light is allowed through the lens to the recording sensor to determine the overall exposure. It affects the depth of field of movie images in the same way as it does for stills. A wide aperture, such as $f/1.4$, will result in lots of light reaching the sensor and a shallow depth of field. However, unlike stills photography, when you're shooting movies you can't just increase your shutter speed to compensate for lots of light, as you will generally want your shutter speed to be double your frame rate (see Tip 2). Therefore, in bright light you will often find that you will be using smaller apertures (such as $f/5.6$–$f/8$) to compensate for the slower shutter speeds in use.

Smaller apertures are also used more often because the extra depth of field they provide makes it much easier to focus. This doesn't mean you should only use smaller apertures, as sometimes a shallow depth of field is exactly what you are looking for in your video. In fact, the opportunity to use wide-aperture, or "fast," lenses rather than those which are typically built into camcorders is the key draw of video on DSLRs rather than camcorders. That said, it depends greatly on the lens you have available. The typical "kit lens" in many DSLRs will only open as far as $f/5.6$.

To extend your creative options, and capture videos like the video-photographs from artists such as Phillip Bloom, which have become popular on the web, you'll need to add a lens capable of opening to

a wider aperture to your kit bag. The cheapest way to do this is pick up a prime lens—a lens without a zoom facility—which can offer an aperture as wide as $f/1.4$ for a relatively small investment.

Beyond the advantages of a wide aperture when it comes to low-light situations, the shallow depth of field that comes with the low apertures is a great way to concentrate the viewer's attention on your subject, and to turn specular highlights (points of bright light) in the background into a mottled pattern.

1 A narrow depth of field blurs the background, concentrating the viewer on the subject, as well as looking slick and film-like.

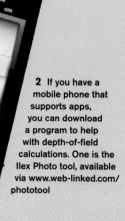

2 If you have a mobile phone that supports apps, you can download a program to help with depth-of-field calculations. One is the Ilex Photo tool, available via www.web-linked.com/phototool

3–5 A narrow aperture in an action sequence like this runs the risk of creating distractions in the shot. A medium setting would have been better.

6 Shooting from a long distance with a telephoto makes a background subject loom large; narrow the aperture and the focus can become jumbled.

✳ Depth-of-field table (50mm lens, 35mm sensor)

	f/1.4	f/2	f/2.8	f/4	f/5.6	f/8	f/11	f/16	f/22
feet									
1	0.2"	0.2"	0.2"	0.2"	1"	1"	1"	1"	2"
2	0.4"	1"	1"	1"	2"	3"	2"	5"	7"
3	1"	1"	2"	3"	4"	6"	8"	1'	1' 5"
4	2"	3"	4"	5"	8"	11"	1' 3"	1' 10"	2' 8"
5	3"	4"	6"	9"	1"	1' 5"	2' 0"	3' 11"	4' 6"
6	4.3"	6"	9"	1'	1'5"	2' 1"	3' 0"	4' 7"	7' 1"
7	6"	8"	1'	1' 5"	2'	2' 11"	4' 2"	6' 7"	10' 9"
8	7.8'	11"	1' 3"	1' 10"	2'8"	3' 10"	5' 7"	9' 2"	16' 3"

50

Noise and ISO

1 This image was shot at ISO 1600 in a brightly lit part of central London, and the quality is certainly acceptable.

2–9 Picture quality deteriorates as the ISO rises, and much more noticeably at the highest settings.

Every electrical system has some form of underlying electrical interference or "white noise," and your DSLR is no different. If, for example, you turn up the volume on your hi-fi without playing any music, you will hear a distinct hiss through the speakers. This is the electrical signal that exists inside the system. DSLRs suffer in a similar way, but you will see, rather than hear, the interference when you increase the amplification.

Noise should be virtually impossible to detect at the camera's base ISO setting—typically 100—but will become more apparent the higher you set the ISO. That's a shame, as ISO is the last of the three settings you can use to adjust the exposure, after shutter speed and aperture, and since it is non-mechanical it can be used to overcome depth-of-field or shutter-duration issues (if you want to shoot with a narrower aperture but the room is poorly lit).

The ISO range on most DSLRs usually starts at ISO 100 and rises to anything from ISO 3200 to ISO 102,400. As with stills photography, increasing the ISO speed enables you to use a faster shutter speed and/or smaller aperture, but while this is often described as "increasing the sensitivity" of the sensor, that's not technically true: the ISO doesn't physically change the sensitivity of the sensor in any way. Instead, it amplifies the signal from the sensor, which can result in image noise.

Therefore it seems obvious that you should try to keep the ISO as low as possible to achieve the highest image quality. However, this doesn't mean you have to always shoot at your DSLR's lowest ISO setting. While higher ISOs will increase noise, this is often not noticeable until ISO 400–800, and it is not intrusive or distracting until you reach ISO 3200 or higher. Perform some tests at different ISO settings and decide for yourself the limit at which the noise level in the movie becomes unacceptable.

However, it is still advisable not to use your camera's highest ISO settings unless you absolutely have to, especially if your DSLR has any "expansion" settings (often denoted Hi on the camera). These expansion settings are there only for extreme situations, and if you need to shoot at ISO 102,400 you should probably introduce some artificial light sources to prevent your footage looking too noisy. While you would be able to shoot at this extreme ISO setting, the results won't be great. Equally, turning the ISO down to the lowest (Lo) setting (50 ISO) is not a good idea either, as this leads to a de-amplification of the signal, which can limit or compress the dynamic range of your footage.

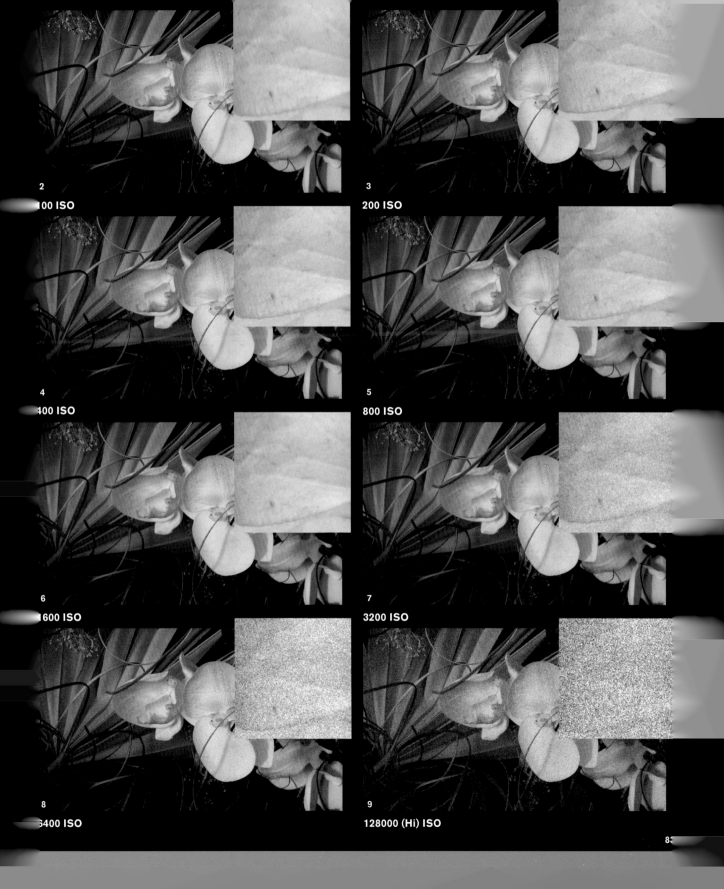

2

100 ISO

3

200 ISO

4

400 ISO

5

800 ISO

6

1600 ISO

7

3200 ISO

8

6400 ISO

9

128000 (Hi) ISO

51

Focusing

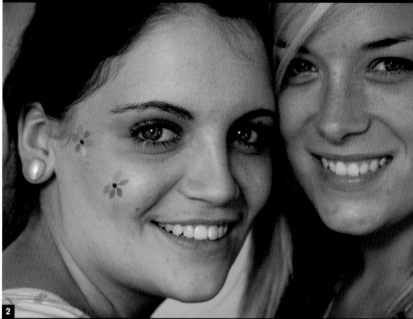

2

1

While your camera may be able to focus automatically when you're shooting movies, you should try to avoid relying on autofocus if at all possible as it is generally slow and will not yield such good results as focusing manually. The problem with autofocus is that most systems work by analyzing lines of contrast in a scene, which means there needs to be a subject to focus on in the first instance. If you are panning across to your subject, for example, the camera won't focus on it until it is in the scene, so you'll end up with a clip that suddenly snaps from having the background in focus to having the subject sharp as it enters the frame. This is the reason why all serious videographers and Hollywood cameramen rely solely on manual focus,

❋ Loupes

Unless you are using an external monitor, you will most likely be composing your shots and judging the exposure on your DSLR's rear LCD panel. This is not ideal in bright light, as the screen can be hard to see, and its relatively small size can make it hard to focus manually. To overcome this, a magnifying loupe will provide you with a clearer view of the screen, without glare, while also helping with critical focusing.

There are numerous models on the market, ranging from budget options to incredibly expensive devices, and which you choose will largely depend on your budget and how much you think you will use it. However, regardless of how much you spend, when you're using a loupe you should take the time to adjust the brightness of your DSLR's LCD screen. If it is set at a very bright or very dark level, you will still end up with an inaccurate judgement of the exposure, no matter how good the loupe is.

❋ Focusing screens

It's possible to buy inexpensive upgrades to some cameras's viewfinders which make it easier to focus on a prime lens, at the expense of brightness. Canon call theirs the Eg-S Super Precision Matte, for example.

so *they* are in control of what appears sharp in the scene, and not the camera.

If you want to focus quickly before you start shooting, use the camera's autofocus in still photography mode and then switch to movie mode—there won't be any change in the focus. Make sure you disable autofocus from the shutter button though, as it's all too easy to enter movie mode, press the shutter button, and find that the camera will try to focus again.

If you're shooting with a wide aperture, and therefore a relatively short depth of field, it's important to make sure that your subject remains relatively still, so ask any onscreen talent to avoid nodding their head in and out of the focal plane. If you're shooting something that does have moving parts—perhaps a detail from a machine—it is worth using a depth of field calculator (or depth of field tables) to set the minimum aperture (see Tip 49).

This might suggest that autofocus would be fine if you wanted to track a moving subject that is already in—and staying in—the scene, but with a bit of practice and, ideally, a follow-focus (see Tip 63), it is possible to track a subject accurately using manual focus, especially if you stop down the aperture to give yourself a little extra depth of field.

All this said, focusing technology is improving rapidly; some newer DSLRs incorporate subject-aware focusing systems not unlike those popular in compacts. These can recognize and track faces and

make necessary tweaks to the focus during the shot, though of course you are putting your shot in the hands of the artificial intelligence programmed in by the manufacturer.

Manual focusing, however, relies on a crisp screen so you can see how sharp the details in your shot are. You can get as close a view as possible with the monitor built into your camera using a loupe—which also has the advantage of eliminating ambient light and reflections—or you can attach an external monitor, which also allows you to view your shot from whichever angle is convenient.

Monitors of all kinds, however, are only as good as their native resolution—even if it is capable of displaying a 1920 x 1080 source image from your camera's HDMI port, it may only have a screen resolution of 800 x 480 pixels. This is the price of portability; you could use a full-size television, but this is likely to be impractical. Even then, some cameras only send a reduced resolution signal down the HDMI cable while they're recording video.

1 Shooting using a loupe makes it easier to see the screen and make focusing adjustments.

2–4 When you've got more than one active character on screen, remember to allow for the depth of field. In this example, focusing on the nearer subject at $f/2.8$ put the farther subject out of focus.

5 An external monitor can make life easier when you are adjusting focus.

52

White balance

The process of shooting video is fundamentally similar to shooting stills, in that you are recording light. The color of light changes depending on the light source—daylight tends to be a cool blue, for example, while indoor lighting has a much warmer, orange color. Our brain takes this into account, but your camera cannot, so you need to make certain you capture the light with the correct colors. When shooting stills, it is very easy to correct the white balance after taking a picture, whether you're shooting Raw or JPEG files, but with digital video, color correction is a much harder and longer process. So, whenever possible, aim to get the white balance right when you are capturing the footage. Your DSLR's automatic white balance setting will do a fairly good job of this most of the time, but there are situations when selecting one of the preset options—such as daylight or incandescent—will produce a better result.

However, if you are looking for the most accurate color, you should move beyond the preset options and perform a custom white balance for every lighting situation you shoot in. With a custom white balance the colors will be as accurate as possible, so all of your movie clips will start out neutral. This gives you the option to creatively adjust the color in post-production, rather than trying to fix a problem.

To perform a custom white balance you will need a sheet of white (or mid-gray) paper or card stock—often referred to by stills photographers as a "gray

card." The process varies slightly between camera brands, but starts with you shooting an image of your neutral card under the same lighting conditions that you will be filming in, filling as much of the frame as possible. You then use this image as the basis for your white balance. When you start filming, you can be confident that the colors will be neutral.

Better yet is to use a color card like the GretagMacbeth ColorChecker. These have a specially printed selection of colors that you can check are consistent in the color-grading process (tweaking the color of each shot in the edit so they're consistent). A cheaper alternative is to print a selection of colored squares onto a sheet of photo paper, including black, white, and mid gray, and keep it safe on your shoot. Shoot it for a few moments at the beginning of each new camera position or new lighting situation, and remember that the light can change over time, especially if the clouds roll in.

White balance is especially significant if you're using different kinds of lighting. The more modern CFL "low energy" lightbulbs are offered at a number of different points on the light temperature scale (see diagram). It's important to make sure that your lighting has a matching temperature or there will be an apparent color shift between the areas lit by one light and another. The effect is even more pronounced between tungsten lighting and CFL.

1 A GretagMacbeth ColorChecker chart.

2–3 With the whilte balance set incorrectly, a shot will look wrong. Our eyes make these adjustments naturally, but they won't forgive different-looking hues edited together.

4 The standard measurement of white balance is the color temperature scale, the temperature at which a theoretical solid would glow if heated to a certain temperature.

2

3

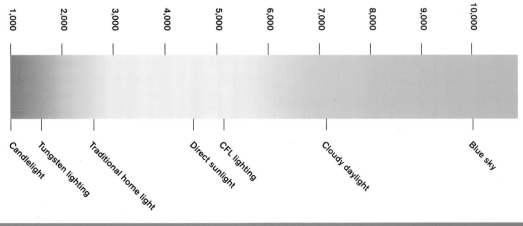

1,000 2,000 3,000 4,000 5,000 6,000 7,000 8,000 9,000 10,000

4

Candlelight

Tungsten lighting

Traditional home light

Direct sunlight

CFL lighting

Cloudy daylight

Blue sky

53

Stability

Keeping a camera steady during movie shooting is essential if you want your film to be watchable. While it's possible to use camera motion creatively—as seen in *The Bourne Identity*, for example—excessive motion in a video clip can induce a form of motion sickness in the audience, so generally you want the camera to be mounted on something secure. Most commonly this will be a tripod, and you may already have one that you use for shooting stills, although there are differences between typical stills and video tripods—and heads—that are worthy of note (see box).

Stability is more crucial, and harder to achieve, in video because the viewer can perceive and be affected by unsteadiness in a way that is impossible with a still photo. The viewer has, literally, a frame of reference around each individual frame of your movie, and if the whole of your shot is affected by camera shake, they'll see it straight away. This is even more noticeable on a television screen than it is on a large projected screen, since those edges are more clearly defined and (unless you're prone to sitting with your nose against the screen) nearer to the center of your field of vision.

To get an idea of just how vital a steady shot is in television production, simply watch television for a while. You'll notice that even in the shots in which the camera moves, it is usually very steady (likely on a dolly or crane). Switch over to the news and you'll see the full scale of production values; the studio will be set up and lit with steady cameras, many of the

pre-planned remote locations will be shot with a tripod for stability but lit using portable equipment, and for breaking news events in dangerous areas you'll see reporters and camera crews using the minimum of equipment, with the highest chance of camera shake. It's partly because of this that we associate shake with gritty, real situations and find it so jarring the rest of the time.

1

1 Camera mounted on a stable video tripod.

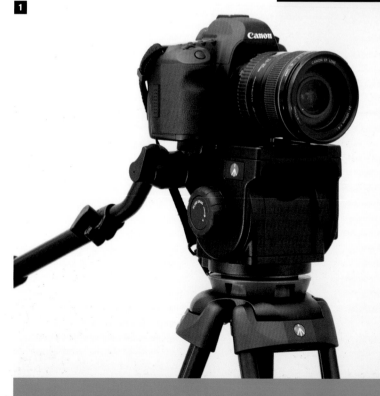

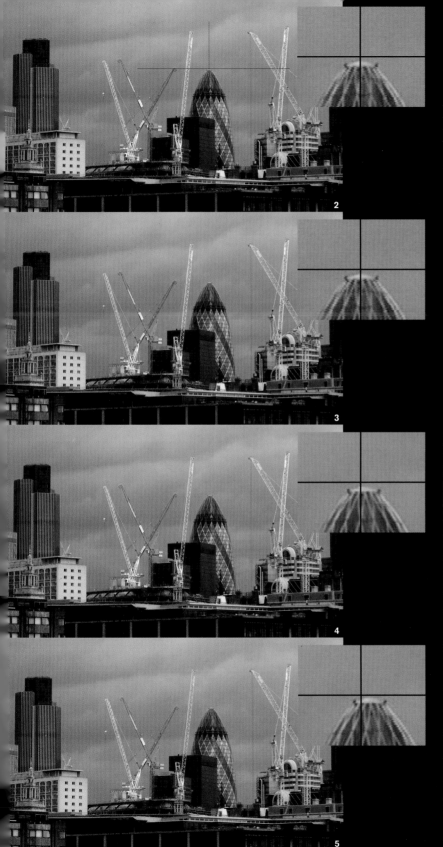

2–5 This shot was taken using a cheap photo tripod rather than a video one. The full-size shots might not at first reveal any vibration, but the close-ups show that the top of the Swiss Re building ("the Gherkin") is moving within the frame.

✳ Video tripods

If you're looking for the ultimate in camera stability, you need to consider a video tripod. Video tripods are usually more substantial than still photography tripods, to help prevent them moving around when you try to pan with a subject using a fluid head (see Tip 54). They also feature a "bowl" between the head and the tripod legs, and if this is fitted with a bullseye or two-way spirit level, it's much easier to level the camera to ensure a level pan.

The downside to video tripods is that they can be very expensive. Although there are models to suit most budgets, you generally get what you pay for, and spending a little bit more is often a better investment than trying to cut costs. If you don't want to spend money on a complete video tripod kit, then perhaps consider getting a fluid head and mounting it on your existing stills tripod. You could also buy a leveling head attachment that will work in a similar fashion to the bowl on a true video tripod, albeit with a slightly reduced level of adjustment.

54

Panning

If you're a stills photographer, you're probably in the habit of putting your camera on a tripod, locking it down, and taking a shot. However, when you look at most TV shows or movies, you will see that there are plenty of shots in which the camera moves, most commonly panning from a fixed point. As long as you avoid camera shake, moving the camera while you are shooting HD video will make for more dynamic footage. Start by just panning (turning) the camera. You can pan to follow the motion of a subject, pan across a static subject, pan sideways, or pan up and down—anything to introduce some movement that will make an otherwise static shot look more interesting.

If you are going to pan with a subject—a person walking, for example—it's a good idea not to follow them for the full extent of their movement. Instead, pan for a while, then gradually slow the movement and allow them to leave the frame. This gives you the option of using a clip where they remain in frame for the duration of the pan, or you can follow them until they leave before cutting to the next clip, which is a great way of indicating a change of location or time.

If you are serious about filming with a DSLR camera, then a "fluid" tripod head that is designed specifically for video work will help you perform smooth camera movements. Fluid heads—as the name suggests—have a fluid-filled section that

creates a dampening effect which allows you move the camera without any judder. It pays to choose one that provides a level of adjustment that will help you perform silky smooth pans, so try out a head before parting with your money—if it doesn't provide you with a smooth motion, or the ability to lock it off or adjust the level easily, you will soon want to upgrade.

When using a fluid head, use the bowl adjustment (on a video tripod) to ensure the head is level, and position your DSLR on the head so that it is evenly balanced—it should not tilt forward or backward if you loosen the head and let go. You may also find adjustment dials or switches on a video head that allow you to adjust the drag on either the horizontal or vertical motion. Make sure you set these dials so you can pan smoothly, but with some friction; if the tripod is set too tight, any panning will be jerky, but if it is too loose you will have less control over the pan.

1 Panning using a tripod with a panning head.

2–5 A shot panning from the model's legs to her head.

55

Camera straps

Although a tripod is a very stable support, it's not always possible or practical to use one, and if you are working to a tight budget you may be unwilling to spend that level of money. However, simply using your camera strap effectively can help you keep the camera steady.

To do this, adjust your strap so it is quite short. Place the strap around your neck and, with your hands on the back of the camera, push it away from your body. The tension this creates will help brace the camera, and because movie filming is done by viewing the scene on the rear LCD panel, you can still see the screen easily while filming. It's not a perfect solution, but it is a lightweight, simple method that, used properly, will even let you pan the camera smoothly by moving from your hips.

✱ Handheld pans

If you are panning by hand, take a deep breath before you start shooting, let about half of it out, then aim not to breathe at all as you pan. Turn with your whole body, keeping your feet in place. If you want a long pan, plan to shoot more than one overlapping segment, moving between each so you face the middle of each shot, as shown below. In the edit, splice in reaction shots from the B-roll (see lower diagram).

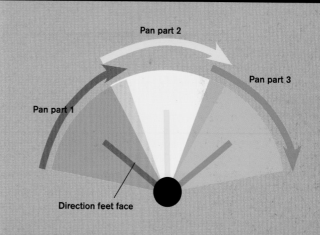

56

Microphones

If you're not using your DSLR's built-in microphone to record sound, you're going to need an external microphone, whether you're plugging it into a sound recorder (see Tip 58) or directly into your camera. There are many choices when it comes to external microphones and this is one of the reasons why professional productions have a person dedicated to audio recording—the choice of which microphone to use can have a huge impact on the quality of your recording. While there is no one microphone that is perfect in all situations, there are three types that are used most often—cardioid, lavalier, and "shotgun."

The model that most people are familiar with is the ball-headed type often used by musicians on stage. These are cardioid microphones, which are used to record sound from one direction—in front of the head of the microphone. Their generally unidirectional pickup pattern means they are useful for recording interviews or live vocals when it doesn't matter if you can see the subject holding the mic.

Lavalier, or "tie-clip," microphones feature an omnidirectional pickup pattern, which means they collect sound from all directions. These are usually worn by the subject, freeing them from the need to hold a microphone, and are suitable for all sorts of productions—from short films, where the mic can be concealed in the actor's clothing, to interviews where the discreet microphone will not distract attention from the subject. Other options include taping the microphone behind something in shot, or suspending it from above a subject on a boom. If you're shooting two people with one "lav" mic, remember that the loudest person should wear it.

For ease of use, lavalier microphones are generally used wirelessly on higher-budget productions, with a transmitting unit sending the sound back to a receiver that channels it to an external recorder. This avoids trailing cables and keeps the set safer. Good-quality wireless microphones, however, are still quite expensive and poor-quality ones will destroy a shoot. Those in the VHF rather than UHF frequency band are highly susceptible to interference from assorted consumer electronics, so avoid VHF altogether. Remember, too, to monitor the sound you're recording at all times.

1 A shotgun-style microphone on a support designed to reduce noise.

2 Check to see whether your camera allows you to attach an external microphone.

Cardioid

**Shotgun
(hyper-cardioid)**

The sound pickup patterns for the key microphone types. Cardioid mics tend to be handheld and are popular for vox-pop pieces, "shotgun" directional mics are often used as booms, and tie-clip mics are usually omnidirectional.

The third type of microphone you might want to use is the "shotgun" mic. These are very directional, primarily picking up sound from directly in front of the mic, and the better the shotgun mic, the more directional it will be. This type of microphone is usually mounted on a boom and used by a boom operator to record voices without the mic appearing in shot. The skill is to point the mic accurately and to get it as close as possible to the source of the sound, without it entering the edge of the frame.

It is worth noting that all of these are professional microphones designed for high-end use, which may well be more than you require. If that's the case, you could consider a small, lightweight, self-powered microphone that can be mounted in your camera's hotshoe. Cardioid and shotgun microphones with this kind of fitting are available relatively inexpensively.

✳ Boom mics

The word "boom" refers to the pole on which the microphone is held, rather than the mic itself, and in theory any kind of mic can be attached. Traditionally, though, despite the broad size of the "Zeppelin" housings associated with these mics, a shotgun mic with a narrow pickup is used, and the boom operator must ensure that the pickup remains pointed directly at the subject.

For easier boom operation, spiral the cable around the pole and secure it with tape or hair ties to prevent noise. Holding it overhead makes it easier to turn (gently) to the person speaking, but is difficult to sustain for a long time and risks causing shadows.

57

Recording sound externally

If you want to obtain good-quality sound but cannot, for whatever reason, depend on your camera's in-built recording system, all is not lost. You will, however, require editing software that allows you to view individual frames and add a soundtrack in post-production.

The principle behind recording sound and adding it separately is wonderfully simple—and, in a way, you already know how to do it, or, failing that, you've certainly seen it done, using a slate or clapper board. All you need to attach externally recorded sound to a clip is to have the correct recording for the correct shot (which is what the writing on the slate is for), and a single moment at which you can be sure that the audio and video recordings are in sync (from that, it can be assumed that the whole clip is synchronized). That is what the clapper is for: slam it down while the board is in shot and there will

be a loud, brief noise added to the soundtrack, and you'll be able to see, to the nearest frame, the point at which the arm swings down.

To complete the process, it's also necessary to say the scene, shot, and take (or whatever categorization you're using) into the microphone so the editor can match up the sound recording to the shot.

Now, strictly speaking, you need nothing more than the "clap." In the early days of "talkies," Hollywood used separate clappers and slates, until someone realized the two could be combined. The striped lines help provide a clear visual under different lighting conditions, though some choose to add colors to help with color grading. For the budget-conscious, a simple clap of the hands in shot will be enough for sound synchronization, and any piece of paper will work as a slate.

When your footage and sound is transferred to a digital editing program, you will see the sound represented as a waveform. You can either line up the waveform against the original soundtrack if there is enough detail in what the camera recorded, or you can use the clap or beep as a sync point.

1 There are digital slate apps available for different mobile phones now, which make a distinct "beep" tone. You may find the clock a useful way to synchronize with sound recordings.

2 Digital recording devices like this Olympus L-11 are ideal for small-budget productions, including as they do their own microphones or a microphone input.

✽ Synchronizing sound

In your editing program, you'll have to put the sound back together. There are several different ways you can approach this, including trimming both the video and the audio to the same "in" point, or by following these steps:

✽ Add the sound recording beneath the video recording—in this case there is also an associated audio track.

✽ Drag the recording until it lines up with the clap mark (or until the audio waveforms line up). Zoom in to confirm.

✽ Delete the original soundtrack and select both the video clip and the new audio track and choose the Link option.

58

Sound recording

Put simply, sound is half of your film, and for all but the most basic projects, it's essential to use some sound recording equipment other than the camera's built-in mic. Quite apart from the less-than-optimal quality, which are a result of the obvious compromises needed to fit it into the camera body, the built-in mic is susceptible to recording all the noises of camera operation. Even the gyro of a lens's image-stabilizing system makes enough sound to be picked up by the built-in mic.

There are some exceptions to this rule: projects in which you are not recording sound at all—either you're just shooting the visuals and audio will be overlaid in the edit, or the project will be entirely silent—and, of course, if you simply don't have the facility to attach an external microphone to your camera. In the latter case, you will still need to record sound properly, but you'll also need to use a slate to sync it later in the edit (see Tip 57).

The key job of a sound recordist is to make sure that the recorded sound falls within the correct levels. Sound volume is measured in terms of decibels (dB), and typically in a relative manner, in which zero is the maximum point of the scale.

The sound recordist adjusts the sound levels according to a meter—this is known as riding the levels—and the art of doing it is knowing when to leave things alone. In regular speech, people's volume will fluctuate within a certain range, so the best thing to do is to ask someone to speak normally for a while on a given subject while you adjust the levels. The hackneyed "Testing… testing… one… two… three" approach is less likely to produce natural speech, so the levels might not be accurate.

Of course, all this depends on your ability to control the audio levels in-camera. Many DSLRs insist on handling the levels for you, through Automatic Gain Control (AGC), whether you like it or

1 A sound recordist should scout the location and warn the crew of any nearby sources of sound. Here, trains will ruin a soundtrack, though if you have a timetable you might be able to work around this.

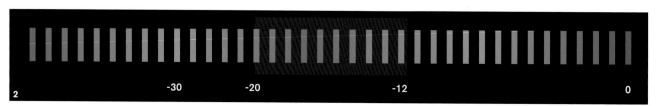

-30 -20 -12 0

2 The ideal zone for sound recording—the level you should aim for voice recording to reach—is between -20 and -12 dB. The orange areas represent acceptable areas for quiet and loud noise, and the red zones at either end should be avoided. It might be acceptable for a really loud noise—a gunshot, for example—to flirt with the top zone for the briefest of moments, but in all other situations you should avoid it.

However quiet it seems, any location will have its own background noise, and it's important to record some of this for the edit. This can be achieved by keeping the tape rolling for a few seconds at either end of each shot, or by taking a few separate shots specifically for this purpose. At least 30 seconds is a good idea, more if you're outdoors or there is uncontrolled noise around. When you come to edit, you'll be able to use this appropriate ambient noise to mask any unwanted sounds in the background (so long as no one is talking at the same time—in that case it's better to re-shoot).

3 A typical sound recordist's mixer, usually worn on a strap over the shoulder. This model accepts three microphone inputs, which are monitored via headphones.

4 This device—the Beachtex DXA-2T—is a useful portable tool featuring XLR inputs, mixing dials, and a 3.5mm "out" ideal for DSLRs.

5 For reasons of size, DSLRs usually have 3.5mm jack sockets for their microphone input.

6 Pro equipment usually uses XLR connectors like this. If you're using a field mixer, you'll probably need an adapter.

not. This means that you can choose between recording sound using a separate device (see Tip 57), or risking the camera making a decision you disagree with. Other cameras allow you to disable AGC, which is essential if you're using a field mixer. Make sure you do so or you will be wasting your effort; the camera will make adjustments on top of those you make yourself.

It's also vital to check your levels. If this were a traditional videography book, I would labour the point about wearing monitor headphones while shooting to make sure that no interference from lighting, ballasts, monitors, cell phones, and so on is affecting

the sound (known as confidence monitoring), but this isn't possible if there's no headphone socket. Instead you need to shoot a brief clip, then play it back and listen. Keep checking your audio at regular intervals during your shoot. Bear in mind that the old principle of Garbage In, Garbage Out is more true for sound than most digital endeavors.

59

Controlling flare

1

The battle against flare is a long-running fight for all photographers, and videography doesn't make life any easier. In fact, in circumstances where you follow a subject across a scene, the chances of stray light affecting some frames within the shot are increased, and the artificiality of that flare is all the more apparent, because it will often move across the frame as the camera angle changes.

One perfectly valid solution is to ignore it. That might sound perverse, but because the effect of lens flare is so recognized as part of the photographic language by audiences, it can simply be seen to add authenticity to a shot. Indeed, in many cases it's deliberately sought as an attractive effect.

The alternative is to use a matte box, essentially a large square (or rectangular) lens hood that is either fixed to rails that are fitted to your camera (making it heavier, but more robust), or clamps onto the front of the lens using an adapter ring (making it lighter and cheaper). Like a photographic lens shade, a matte box is designed to prevent stray light from hitting the front of your lens and creating internal reflections (lowering the contrast of the image) or causing lens flare. In addition, a matte box also incorporates filter mounts so you can make use of any filters, such as neutral density, polarizers, or grads.

Now, you might be thinking that you already own a lens shade and possibly a filter system, so what's the point of buying an expensive matte box that appears to do the same job? Well, the important difference is that video shooting often involves camera movement, so the angle of the light hitting the lens may change while you are shooting. Because of this, a matte box designed for shooting video should also have one or more adjustable panels, or "flags," attached to the front. These can be positioned to more accurately shade the lens, which is essential when you're shooting video, as correcting the contrast of your movie footage is far more time-consuming than adjusting a photograph.

1 Sometimes flare can add to a shot.

2 A matte box fitted to the front of a DSLR.

3–4 A shot taken without, then with, a matte box.

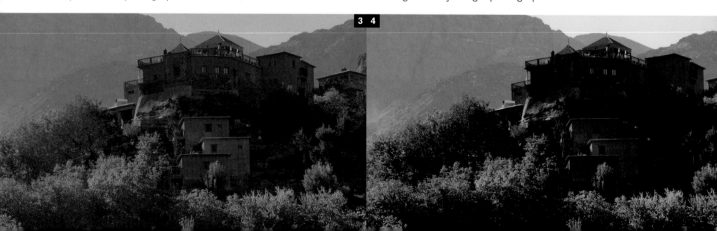

3 4

60

Neutral density filters

When you're shooting movies with your DSLR, you can select from a wide range of shutter speeds (see Tip 47), but most of the time you'll probably be shooting at 1/50 sec or 1/60 sec. When you're shooting in bright light, this can often mean that you have to stop the aperture down to get the correct exposure, even with the ISO set to its lowest sensitivity. This isn't a problem as such, but it can limit your ability to use a shallow depth of field (from a wide aperture).

The solution is to fit a neutral density, or ND, filter to your lens. An ND filter acts in a similar way to sunglasses, in that it cuts down the amount of light coming through the lens, allowing you to shoot at a wider aperture setting (even in bright light). There are essentially two types of ND filter available: fixed and variable. As its name suggests, a fixed ND filter reduces the amount of light coming through the lens by a specific amount, so a 2-stop ND filter will cut off 2 stops of light—meaning you could use an aperture of $f/5.6$ instead of $f/11$, for example. This is useful, but if the light changes while you're shooting, you will need to change the filter.

More versatility comes from the more expensive variable, or Vari-ND filters. Unlike a fixed ND, you can rotate a Vari-ND filter to control the amount of light it transmits, much the same as rotating a polarizing filter in still photography. Indeed, Vari-ND filters are effectively a linear polarizer and circular polarizer screwed together, and it is by adjusting the polarization that you regulate the amount of light

passing through. Depending on the model you choose, you can find ND strengths from 1 to 8 stops in a single filter.

With the versatility and smooth exposure adjustment a Vari-ND offers, it is quite possible to use a Vari-ND to carry out all of your exposure adjustments during filming, rather than using the aperture, shutter speed, or ISO, simply by using the Vari-ND filter to compensate for any changes in the light. This can also give a better-looking result, as your exposure changes will be gradual, not stepped.

An ND filter.

61

Moving camera shots

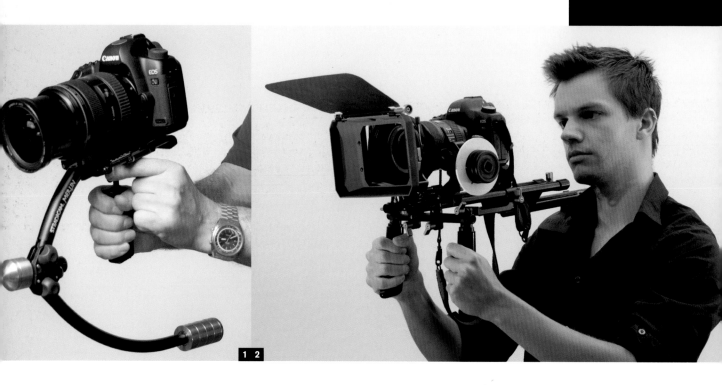

1 2

There is an increasing number of ways to free your camera from the tripod mount and obtain high-quality moving shots. These methods vary in cost and complexity, and you should think carefully about what you need from your unit before you buy. If you shoot a lot of interviews, you may want the ability to follow your subject in a walk-and-talk scenario, but you may not need the full steadicam effect. To keep your camera on the move and the shot smooth, however, a steadicam-style device is a necessity.

A steadicam is essentially a gimbal head that allows you to hold the camera neutrally balanced, and when it's set up properly around your camera's center of gravity, you can walk around and control the camera very smoothly.

Steadicams are available from several different manufacturers, and you can even make them yourself (there are lots of instructions online on how to do this), but learning to "fly" a steadicam takes practice. The key is to make sure the system is properly balanced before you start filming, then you can control the direction and motion of the camera using your fingertips, using the lightest pressure to guide, rather than force, the camera into position.

Perhaps the most popular option is the shoulder mount. This enables the HDSLR to be used in the

1 Shooting with a steadicam-style adapter shifts the camera's center of gravity.

2 A shoulder mount also enables you to move the DSLR in the same way as camera operators working with larger video cameras are used to doing.

There is a big difference between the shape of a professional video camera and a DSLR, and there is a good reason for this: when you're shooting for long periods of time, it is easier to have a camera sitting on your shoulder than to hold it with both hands in front of your face. Handholding a camera requires muscle tension, which can become tiring over time and lead to increased camera shake, whereas resting something on your shoulder means the weight is better distributed, more comfortable, and more stable.

If you plan to shoot "run-and-gun"-style documentary footage, or are involved in ENG (Electronic News Gathering) work using your DSLR, then a shoulder mount can be one of the most appropriate solutions, effectively turning your DSLR into a video-camera-style tool that is better balanced and easier to use. While it is heavier than shooting purely handheld, if you are planning on shooting video exclusively, it is very effective in helping you achieve more stable footage. Shoulder mounts can be combined easily with a follow-focus unit (see Tip 63), and most models will also provide a place to mount accessories such as video lights, external monitors, microphones, and audio recorders.

Although quite expensive, a shoulder mount's skeletal design is very effective and means they have an inherently light weight that helps prevent them becoming too cumbersome. As with a steadicam, the key to getting the best from a shoulder mount is to make sure you balance it when you're bolting it all together with the camera and lens. If the camera is too far forward, or too far back, the system will be front- or back-heavy, making it harder and more tiring to use. This is especially important when you change lenses, particularly from a small wide-angle lens to a longer, heavier telephoto, or vice versa, as the balance can change dramatically.

same way as traditional broadcast cameras. These cameras are much heavier and are shoulder-mounted for steadiness, as it would be almost impossible to hold them up as you would naturally do with an HDSLR for any amount of time.

The shoulder rig uses your body as a brace and allows for much greater stability than handheld use for lightweight cameras, as well as providing a mounting point for microphones, follow focus, lights and monitors. Adopting this system allows "run and gun" shooters to be guaranteed a steady shot without carrying a tripod.

The steadicam-style systems that made their name in cinema productions like the original *Terminator* are expensive and complicated. They require a trained, experienced operator for the best results.

Cheaper handheld systems like the Merlin steadicam promise similar results using simplified versions of the same technology. Such units do provide some of the "weightless flight" look you'd expect, but with some compromises. Longer setup times and imprecise manufacture can hamper your shot as success depends on a perfect balance of weights. Often these adjustments will be made by physically moving small weights, as opposed to wireless micro-motors on the professional models.

Pleasing results are possible—the key is practice, patience, and, in the case of the Merlin, a very strong arm!

The "fig rig" manufactured by Manfrotto (similar products are also available from other manufacturers) is a popular compromise. It is not a steadicam, but allows the operator to brace the camera with both arms for steady pans and movements compared to shoulder-mounted shots. It also provides a mounting point for mics, monitors, and other equipment. These systems are fairly cost effective, and a good halfway house for events, or a wedding videographer. They also require much less practice, and little or no setup time.

62

Sliders

A slider is a popular and relatively inexpensive way to add a professional feel to your movies. It allows you to track the camera sideways smoothly. This has a great cinematic feel to it, replicating the dolly shot achieved by laying track and running a wheeled dolly with the camera and operator along it, the method used by professional crews.

If you are a wedding videographer, for example, you can replace your 360-degree pan around the congregation with a "slide" past a group of people, perhaps incorporating a focus pull. Done smoothly, the client will be reminded more of a feature film and less of a family video. Slides are also very useful in the edit, providing a different way to cut between locked-off shots, to give just one example.

Slider products like the glide track and indislider take the form of a length of metal that the video head slides along on a carriage, usually on nylon friction bearings. Prices vary and it is worth trying the product first-hand before buying to make sure the manufacturing quality is sufficient for your needs. If you are planning macro or close-up work, for example, you may find that tiny vibrations and stutters not visible on a wide shot are severe enough to ruin your take. Likewise, an overly heavy or lengthy track will restrict you if you plan to shoot on location. Remember that many sliders require a tripod or heavy lightstand at either end to guarantee good results, despite some manufacturers' claims.

If your budget does not allow for a slider, it is one of the products that you really can make yourself. You can use alternative materials, like wood (see box), or even hunt down the extruded metal section and the carriage that rides on it , which are used for many different industrial purposes—a quick internet search will reveal many forums discussing places to obtain them. Essentially, you purchase the section and carriage, drill through the carriage so a video tripod head can be attached, choose a way to make it tripod-mountable, and away you go!

1 A camera mounted on a glide track slider.

2 A shot taken from a slider, as the camera slowly moves past a row of cans.

3 A glide track runner with low-friction surfaces to grip but move smoothly on the track.

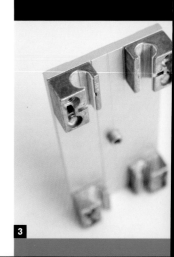

✳ Build your own

All good film directors have at some point had to improvise, and finding ways to create slider and dolly (see Tip 65) shots can add a professional touch to any production. You will need two tripods, a piece of solid wood to act as the track, a smaller piece of wood to act as the glider, some Teflon tape, and some baby powder.

Drill two holes in either end of the wood, wide enough that you can mount your tripods to them.

Attach a steel L-shaped plate to one edge using screws. The plate should be taller than the wood's thickness.

Take the block of wood you have chosen to act as your slider—it should be good, heavy wood in a rectangle of at least 1" x 4" x 6"—and drill a hole in it so that you can fit the bottom of a tripod screw into it.

Now turn the block on its side and attach the Teflon tape to create runners. You might also need to attach the tape to the front of the block as it will run against the L-plate.

Attach your tripod mount to the top of the runner, and use the baby powder to lubricate the surfaces.

glide track fixed to [so]id base for rigidity. [Th]is important— if the [track] bends, the runner [will] stick.

5 The runner (with screw fit for tripod head) grips the track, and can easily be pushed in either direction.

6 The camera is mounted to the runner using a tripod head, and this is used to adjust the viewing angle.

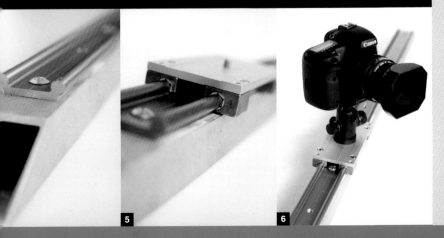

5 **6**

63

Focus pull

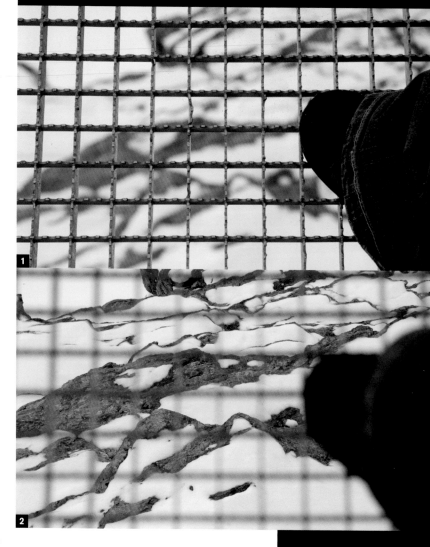

One of the major plus points of HDSLRs is that the sensor size, along with stills lenses, give you the possibility to create shallow depth of field that is more or less impossible in standard video cameras.

This ability to selectively focus throughout a scene adds to the cinematic feel of the footage, and gives you more scope for creativity.

There are two main things to look out for in this respect. The first is simple enough: avoid the temptation to shoot wide open at f1.8 all the time, just because you can! New DSLR video users often shoot like this at first, particularly if they have struggled with "everything sharp" small-sensor video cameras before. However, if you watch a feature film you will notice that this trick is not used all the time, but selectively and intelligently to better tell the story.

The second is a logistical problem: camera movement. Professional cine-lenses are built to pull focus silently, and with no lens "breathing". This means the end of the lens does not move when focusing, but this is not the case with stills lenses, which can push out against matte boxes and potentially cause damage.

The act of focusing will also usually move the camera slightly. A weak point of the DSLR body is that it can only be fixed at the tripod screw plate, which can lead to inadvertent wobble, no matter how smooth and accurate the focus pull.

Bear in mind that microphones mounted on or near the camera may pick up the sound of your focus pull, and plan around it where possible.

Plenty of focus-pull rigs are available; these typically use a system that attaches a geared surround to the lens barrel, which meshes with a focus pull you control. The better rigs have a plate so you can mark your start and end points for accurate, repeatable pulls.

1–2 A focus pull shows the foot at the beginning of the shot and the rocky surface beneath at the end.

3–5 A follow-focus in use.

✳ Follow-focus

As we saw in Tip 51, it is far better to focus manually when you're shooting video than it is to rely on your camera's autofocus. Ergonomically, though, it is quite difficult to focus manually with an ordinary DSLR camera lens, and even harder to track a moving subject when you're using lenses designed primarily for still photography. This is because many modern lenses don't have mechanical linkages between the focus ring and the focus motor. Instead, they rely on an electronic connection, and while this is great for autofocus, when you want to focus manually it doesn't offer the feel or precise control needed to track a subject.

To help overcome this, there are various focusing aids available, based on professional cinema camera follow-focus units. A follow-focus unit consists of a side-mounted dial and gears to turn the focus ring on the lens, making it much easier to focus with greater precision. A follow-focus unit also makes it much easier to track a moving subject—especially if you are shooting multiple takes—as you can add focus marks. These are marks that are made on the follow-focus to correspond to specific distances along the path that your subject will take during a shot. Assuming your subject hits their marks, you can simply adjust the follow-focus to the marks you have made, knowing the lens will be focused at the right point, rather than watching intently and adjusting the focus by eye for each and every take.

64

Changing settings while filming

1

4

When the Canon EOS 5D MkII was released, the video function was hampered by its lack of manual control. The camera would constantly evaluate the scene and adjust itself for "best" exposure, much like a small video camera on your mobile phone or laptop.

To better understand this limitation, picture a scene in which a model is walking down a brightly lit catwalk. The photographer will want the lights to overexpose and the model to be correctly exposed. The camera will evaluate the scene and, taking its cue from the strong background lighting, stop down. This renders the model too dark and defeats the point of the video. To counteract this problem, users were forced to adapt older lenses with manual iris control, or use the "lock exposure" feature by pointing away from the scene, locking, and coming back. Obviously this disrupts shooting considerably and prevents a smooth workflow.

In response to many customer requests, Canon released a firmware update that allowed the ISO, shutter and iris to be operated manually during filming. The camera benefited enormously from this finer level of control. Going back to our earlier example, the photographer can now evaluate the scene himself and select the correct exposure quickly, capturing the shot without delay.

Lighting conditions will change constantly on most shoots, and the ability to react and continue filming is vital. Shoots like weddings or events will often follow people in and out of doors, and through rooms where light levels and temperatures will shift, and changing settings on the fly will prevent gaps in your edit later on.

1–8 The focus pull is a classic example of a change in settings during a shot, and manufacturers are now bringing out lenses better adapted to this kind of work.

3

6

8

65

Dolly

Strictly speaking, a dolly shot is any shot in which the camera moves, and can include the slider mechanisms discussed in Tip 62. That said, the term is most commonly associated with the movement of the camera along a track support which is built to be as smooth as possible.

We know that moving the camera while you are filming can create much more interesting footage than locking it on a tripod (see Tip 61), but if you want to move the camera you need to make sure it is a smooth, stable movement and not a jittery, jerky action. There are many methods you can use to achieve this, but the two most commonly used are a glide track or a dolly and track that allow a slow, continuous movement. Movie studios will often lay long sections of track for a wheeled dolly to slide along, but for the HDSLR shooter, a sit-on dolly is going to be overkill both in terms of its cost and complexity. However, a glide track, a small tracking dolly, or even dolly wheels on your video tripod, will all allow you to move the camera smoothly during filming.

A glide track is essential two rails with a mounted carriage on which you mount a video head. The rails come in various lengths, but for most projects you'll find that one yard (or one meter) is more than long enough. If, however, you want greater freedom and you're working on a flat, smooth surface, you may find that dolly wheels on a tripod, or a small dolly carriage that you mount the camera directly onto, are useful alternatives.

If you don't want the expense of buying (or renting) a glide track or dolly, but are good with basic hand tools, then it is quite possible to fashion a rudimentary glide track out of low-cost items such as plumbing pipe and rollerblade wheels; a quick search on the internet will reveal a number of ways that you can do this. An even cheaper solution is to mount your DSLR onto a skateboard and roll it along. Obviously this will limit the height of your camera, and you need to be careful not to tip the skateboard as you push it, but on a smooth surface you can achieve a smooth camera movement.

1–2 A professional dolly track from Libec. A standard video tripod can be fitted into the dolly.

3–4 This homemade dolly uses cheap, lightweight aluminum tubing and standard plastic joins to form the frame. The wheels are standard skateboard wheels attached to metal L-plates. © http://www.tdepost.com/

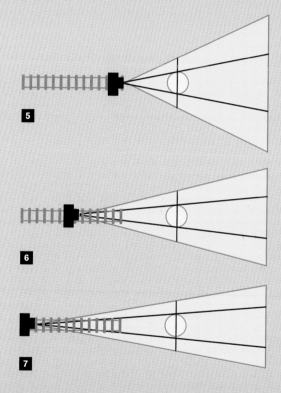

5-7 As the camera moves back along the dolly track, the zoom is adjusted so that the framing remains constant at the green line. The perspective shifts so that a smaller proportion of the background is visible.

❋ Dolly zoom

By combining the movement of the dolly with an opposing movement of the zoom, you can create an interesting effect known as the dolly-zoom. This takes advantage of the different characteristics of a lens at its wide range—which tends to open perspective—than the telephoto end, which flattens it. The result is a deliberately unsettling shot (in fact it's sometimes known as a "vertigo effect") in which the subject appears to remain the same size while the perspective changes.

Examples of this kind of shot in films include Alfred Hitchcock's… wait for it… *Vertigo*, and Stephen Spielberg's *Jaws*—specifically the very jarring shot of Captain Brody (Roy Scheider) sitting on the beach while his kids are in the water as the "Shark!" alarm is raised.

8 In this dolly shot of a messy kitchen (the shot was edited to fade to a clean version of the same kitchen), you can see the perspective on passing items and cupboards shifting in a way that wouldn't happen in a pan. This makes the shot more immersive and less like a survey of the scene.

66

External lights

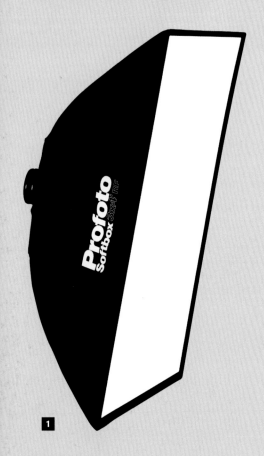

Lighting for video can be very different than stills lighting. Although many of the principles remain the same, the camera may now move around the scene, rather than always being locked down. Stills photographers with flash equipment will have to get used to new, continuous sources of light. The good news is that there are more options available now than ever before—LED and fluorescent units have joined the traditional tungsten kit and gone professional. There is much debate over the relative merits of each system, but it's clear that cheap, lightweight LED units and some cheaper fluorescent sources provide the HDSLR shooter with some interesting alternatives to "hot lights" or tungsten.

Brands such as Kinoflo produce various sizes of prediffused, color-balanced fluorescent light. Domestic fluorescent fittings constantly vary in color. This is imperceptible to the eye, but if used for filming, the shift will quickly become obvious. The pro versions have eradicated this problem and give a beautiful soft light. They also weigh very little and can be made small enough to take and use almost anywhere. They can be very expensive, even compared to tungsten lights, but beware of cheaper brands, as you may get color fluctuations that are almost impossible to correct afterwards. Constant color change is harder to correct than just all the lights being a bit warm; the latter can be fixed if you remember to use a color-checker as described in Tip 52.

LED lights are the latest entry to the market and the least understood. They are often criticized for

1 A softbox is the classic form of photo lighting.

2–3 The difference between room lighting (2) and studio lighting (3) with softboxes is easy to see.

3

their color inaccuracy and lack of light "throw" compared to other options. This is often due to them being a largely domestic/industrial product which is easily repackaged as a "pro" lighting tool. It is fair to say that buying good-quality fixtures will get you much better results. At their best, they are long-lasting and very durable lights. It is also worth knowing that they are perhaps the best lights for "on-camera" use as they use the lowest power of all the options. In addition, they run cool, protecting your equipment, and, in an enclosed space, your talent.

Tungsten lights are still the most popular option, and well worth considering for the HDSLR shooter. There are plenty of kits available and a wealth of secondhand options. Bulbs are the big expense, and the heat of the lights the main worry for the inexperienced. The bulbs and fixtures have been refined over a long time and can be relied on for

color consistency. Accessories such as scrims and barn doors give you control over a light source that, for the most part, will be much brighter than you need, given the revolutionary low-light capabilities of your kit.

Beyond simply choosing which lighting technology you're going to use, you'll also need to think about what kind of light you're looking for. One of the most common scenarios is lighting someone speaking to the camera. In order to make sure the light is flattering, it will need to fall from roughly their height; it's unlikely that the ceiling lighting in a room will produce anything other than unattractive shadows.

67

Time-lapse

1

1–10 Cloud formations are a perfect subject for time-lapse photography.

If you want to show the passing of time in a film, shooting a time-lapse sequence is a great option. With a DSLR camera, there are two ways to shoot time-lapse: either by photographing a series of still images at defined intervals—the standard method of creating a time-lapse—or by shooting a long video clip that is sped up in post-processing so time appears to pass much quicker. Both methods have their advantages and disadvantages, so try both to see which works for you. Whichever you choose, be sure to use a solid tripod, as any slight camera movement will become very obvious when the clip is played back as a continuous sequence.

If you are going to try shooting a series of stills, the one thing you will need is an intervalometer. This is a camera timer that will trip the shutter at predefined intervals, saving you having to wait by the camera and trigger it manually. Intervalometers are available from a number of manufacturers, with both wired and wireless models available to fit most cameras. When shooting, you first need to decide on the interval between each shot. The simple rule is the more shots you take, the smoother the result will be when it is played back. At the same time, though, shooting more will take up more space on your memory card, so you will usually have to compromise on how long you want the time-lapse to last and how much of a gap you want between each frame.

You can choose any shooting mode you like for time-lapse sequences, but be aware that using any of your camera's automatic or semi-automatic modes may result in a flickering effect in the final sequence if the exposure changes between frames. To avoid this, you can use manual mode, although if you are recording a long time-lapse sequence the exposure may still change, especially if you plan to shoot through sunrise or sunset, as the light levels increase or decrease and the exposure setting doesn't change. There are two ways around this: either weight the exposure so neither the day nor night shots are perfect, but you find an acceptable middle ground, or shoot two time-lapse sequences—one before sunset (or sunrise) and one after. You can then blend them together with a dissolve during the editing process to make them run into each other less obviously.

Once you've shot your sequence you will need to process it, and this can be a very time-consuming task. However, remember that if you are simply planning on using this sequence in an HD video, you do not need to shoot the stills at the highest resolution of your camera. In fact, a small JPEG file will be more than enough given that an HD movie has a resolution of around 2 megapixels. If you want to be able to "zoom in" digitally, a higher-resolution original will help, but in most situations a smaller setting will work perfectly—and still allow you to digitally zoom or pan and scan around a frame.

2 3

4

5 6

7

8 9

10

To see a sample film, follow this link:
http://www.web-linked.com/vidt/clip67/

✽ Video time-lapse

If you want to try time-lapse by shooting video and speeding it up at the editing stage, your main consideration needs to be the maximum recording time your DSLR allows—usually around 12 minutes (see Tip 11) depending on whether you want sound or not, and the frame rate you are using. However, even with the sound off and a frame rate of 24fps or 25fps, you will be unlikely to achieve more than 15 minutes of footage at most.

The problem is that once this is sped up in post-processing to produce the time-lapse effect, it will only provide you with a short clip. Equally, if the subject you are filming is moving very slowly, you may find that 12 minutes of footage is not enough to show an adequate passage of time, so this method is best reserved for faster-moving subjects.

68

Stop motion

1 Emily, the Corpse Bride, reveals her atmospherically lit face.

2 Victor plays a song to apologize to Emily for lying to her.

Stop-motion filming is a popular method of making animated films or sequences, although strictly speaking it's not an HD video technique. Instead, stop-motion is a series of still images of objects that move slightly between each frame, and when these individual frames are played back as a movie, it gives the impression of movement.

To make a stop-motion film you really need little more than a camera that is capable of taking a still image, a lens, a tripod, and a whole stack of patience. Because you have to take lots of frames, stop-motion is very time-consuming, so it's a very good idea to have a well-developed storyboard that maps out each shot to make sure you don't over-shoot and waste a lot of time. When it comes to shooting, you need to be very careful with the exposure, which should be set manually to avoid the exposure flickering if the camera auto-adjusts when you move your subject(s) around the frame. You also need to make sure that the camera doesn't move between frames, so use a stable tripod and be careful not to knock anything between shots!

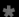

The first Hollywood feature to use DSLR cameras for principal shooting was not a traditional motion picture, but Tim Burton and Mike Johnson's 2005 feature *Corpse Bride*. Of course, that predates video-capable DSLRs, but that's no obstacle in the case of stop motion.

Each frame was shot on a Canon 1D Mk II—then Canon's top-of-the-range digital camera—as a still, then animated together, a process which meant that shooting took 52 weeks (a normal feature takes about 10–14). The digital SLR was selected in preference to film, which was tested in the preproduction phase.

The entire script was planned to the nearest frame and sketched out in an extended storyboarding process. These frames were scanned and the edit could begin by using them as placeholders, thereby avoiding wasting time shooting material which wouldn't be used—a serious consideration when you're getting two minutes of footage a week.

Between each shot the puppets were repositioned; they were constructed with a stainless steel skeleton and silicon skin. A device that allowed a camcorder to be pointed through the viewfinder and relayed to a monitor was constructed to relay live video to animators composing the frame; now, the same result could be achieved with the Live View feature on more recent cameras.

As the project was shot, the placeholder frames in the edit were replaced with photographs until the movie was ready to be converted for distribution.

69

Weddings
and events

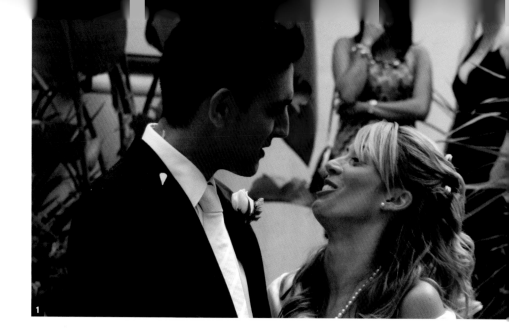

1

Wedding photography is fiercely competitive, and the arrival of HD video-capable DSLRs was seen by many as an opportunity to extend their portfolio. Doing so successfully, however, presents many challenges, and is virtually impossible for those shooting alone unless they prioritize one or other medium. That's because you cannot shoot video and stills at the same time.

If, however, you are able to work with an assistant or partner, and plan ahead, you can capture all the footage you need to compete with established video producers and still have a complete photo album to offer. (If you're a videographer by trade, the DSLR is best suited to adding some artistic shots of romantic moments into the editor's hands).

In either case, the most important thing about an event is to plan for it. Make sure you're never running on your last battery or memory card with half the day to spare, and if you're shooting video, these problems are exacerbated. You can easily shoot more than 160 GB of footage per camera (at 38 megabits or 4.75 megabytes per second data rate), and expect to drain up to 10 standard camera batteries. A battery grip will help to reduce this problem, but you'll still need all that power to hand, you just won't need to stop and change so often.

Clip limits, too, pose serious logistical challenges. Most wedding ceremonies, for example, last longer than a DSLR can record continuously. One tactic you might adopt is to record the sound using an external device, and take some shots of the congregation just before the ceremony which can be cut in while you change cards. Overheating, too, is a serious issue; remember to switch out of Live View mode as often as you can to give the camera time to recover. Some models (like the Nikon D90) simply shut down when they get hot, while others keep recording but the noise increases.

A safer solution is to use more than one vantage point, and perhaps a standard HD camcorder can be left recording with a relatively wide shot (or a reliable one, focused on the couple), while using the DSLR for creative close-ups like the ring exchanges, reaction shots, and the kiss.

1–4 You'll need at least one good kiss for any wedding video, so be sure the camera is pointed at the couple at the right moment.

5 Brief clips of your colleagues at work can serve to add glamour to the video, so don't be afraid to point the camera at them while they're at work.

5

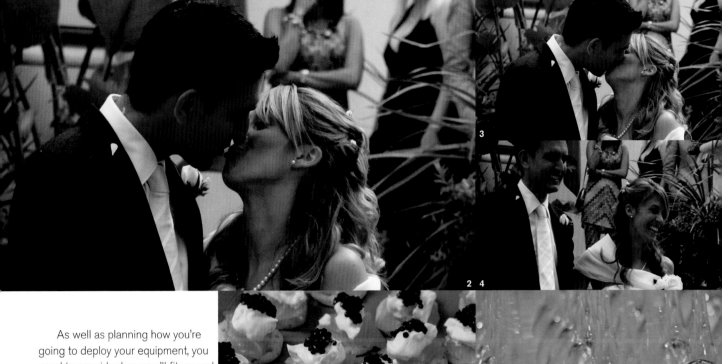

As well as planning how you're going to deploy your equipment, you need to consider how you'll fit around the day, and what you can deliver in terms of a video. Even though you're shooting events as they happen, you still need to be thinking about a unifying "story." One option, for example, is to shoot the bride and groom's separate preparations and then intercut the shots in a single sequence. If you're stretched and have only one camera, you might even be able to do this by moving between rooms in the hotel.

The preparation phase translates very well on video, so is a great way to pick up some B-roll. If you arrive early enough while chairs are being put out and decorated, a clip of each of these can be edited together to form a touching montage showing how much effort goes into the day. Or the shots can be intercut with the bridal preparations (even if the logistical things happened hours earlier; this won't matter in the edit).

For the body of the piece, however, you're going to need to know exactly where you're going to be during the set-piece moments (in a wedding, these are usually the ceremony, the toasts, and the first dance). Before the ceremony starts, make sure any remote cameras (the camcorder) have enough storage and are secure on a tripod. Set them recording and take your own position.

By their very nature, events do not allow a second take. In some ways, DSLRs have a lot in common with the earlier days of film production, in which multiple takes were *de rigueur*. The solution is to have confidence in the shots you're taking. If you don't think you can get a certain shot, don't do it. Every shot you can get is a moment that you don't need the wide angle in the edit.

A camera-steadying device (see Tip 61) is certainly a great way to make sure you can quickly get sweeping, artistic dolly-like shots and retain the flexibility to keep on top of the day.

After shooting, be prepared to spend a long time syncing sound and audio, as well as just going through your material. A good way to minimize the amount you'll need synced sound is to create a video-photo of the wedding, centering your edit around a recording of the vows or a toast, while simply using the visuals from clips of preparations, and even the ceremony. Where you've got no film, you can pan-and-scan photos.

6–7 Details of every element of preparation should be included, and a focus-pull across the glasses looks good. Someone watching will have been involved in these details.

Short / Daniel M Childs *Matches*

 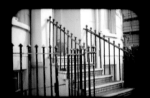 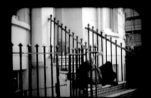

***Matches* was created for** the Brighton Filmmakers' Coalition March 2010 film challenge. We were given two weeks to create a film based on "The Little Match Seller" by Hans Christian Andersen. Originally there were supposed to be five people in our group, but three of them had to drop out due to other commitments, which meant that Liva and I were left without a video camera to work with. Liva suggested making a stop-motion animation using my Nikon DSLR. I had never seen any live-action stop-motion films before so didn't really know how it would work, but I thought we should give it a try. It turned out to be a really interesting and rewarding experience.

The first thing we needed to do was to create a storyboard of scenes that were both interesting and possible to achieve with the meager budget that we had available to us, so a few days later we sat down together in a local pub and started to get creative. We chose quiet locations and shot mostly early in the morning when we would have minimal interruptions from the passers-by. On the whole we used what we had available to us in the way of props; the

only additional purchases being the black Morphsuit worn by the skateboarder and some chocolate eggs to make the match heads. I would estimate the total cost of the film at about £40 ($60).

The shots were all taken using my Nikon D200 DSLR using a 35mm F2 Nikkor lens. I used the small, medium-quality JPEG format, which meant that the frames were only slightly larger than 1080p resolution. Taking the photos in this format meant that the import times to computer were minimized and also that more continuous shots could be taken in one continuous burst. We ended up with over 2000 shots.

The scenes were composed in the same way that I would compose a standard photograph; making sure that each composition was strong and uncluttered, and paying good attention to light and color. Even more care must be taken when setting a stop-motion scene than with a standard photograph, because if something needs to be changed later it will have to be changed on many frames.

I had the camera set to manual focus so that I had fast and accurate control and

could smoothly change the focus while shooting in continuous mode. The length of time between frames would depend on the desired effect within the scene. For example in the scenes where the match seller is walking under the colonnade, the camera and actress had to be moved by half a foot between each shot and we deliberately took the time to move her hair each time to make it seem like it had a life of its own. In contrast, the scene where the skateboarder steals her shoes was shot using the camera's continuous shooting mode at 5fps, to give it a much softer, more delicate effect. As in most stop-motion animation, it was essential to use a tripod to prevent unintentional movement of the camera between frames. Even the slightest movement can lead to the viewer becoming disorientated and distracted.

The film was shot over four days and after each day's shooting I would import the photos into Adobe Lightroom, where I had created a preset that would change the colors and add the vignettes to each shot. I would then export all the pictures that I had decided to use in 1080p HD resolution (1920 x 1080) to a folder on

my desktop ready to be imported into Adobe Premiere Pro. I imported the still frames into Premiere scene by scene, each set to playback at 8fps, organizing them or duplicating them if necessary before exporting each sequence as HD video. I then created a new project in Premiere and imported all of the scene sequences into the pallette window before editing them together. The music was created using Reason and the resulting WAV file imported into Premiere.

To see the movie, visit:
http://web-linked.com/vidt/matches

By adjusting the focus and exploiting the camera's fluctuations in exposure settings, a charming old-time movie effect was achieved.

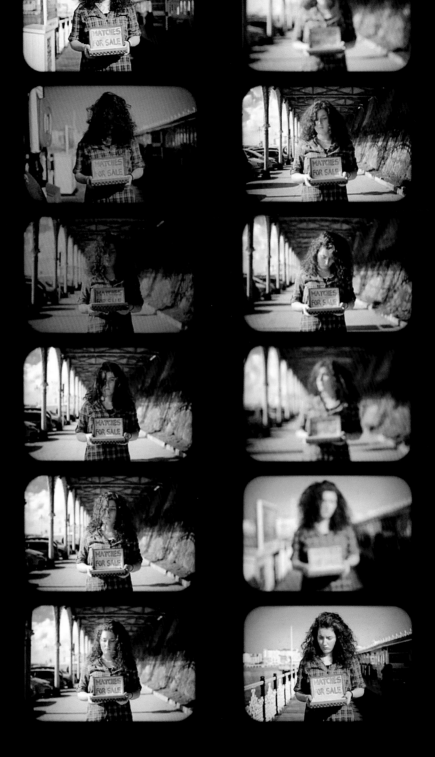

Chapter_

70

71

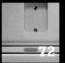

72

73

74

Square

None
75

30fps 48KHz

eset when edit
set to 48 76

77

78

Bir
79

Editing

80　81　82　83　84　85　86　87

88　89　90　91　92　93　94

70

Planned workflow

It may seem an obvious point, but it's worth stressing: if you work in a consistent, planned manner, you will find things happen faster, are more reliable, and you will make the best use of your storage and your system. If you approach each project differently and don't take the time to name files or label storage cards, you will not only lose vital files, but also quickly fill up your computer with unnecessary junk which is difficult and time-consuming to remove.

Once you've finished shooting, a time when it's more than likely you will have had to make changes from your plans in pre-production, the transferring of files to your storage system is another opportunity to impose order on your project. If you're simply working from clips you've shot opportunistically, this is really your first chance.

In either case, your primary concern is getting your clips stored in a medium where you can easily access them with player and editor software, back them up, and review them. You'll likely also need to be able to clear your memory cards so that they can be re-used; to avoid any serious blunders, remember to take simple measures like keeping two piles on your desk and moving files to the "copied over" pile only when you've copied all the files across to your main target and backup locations.

If you're an experienced stills photographer, you may find the sheer size of the files a challenge; in the past, it was possible to keep files in folders of DVD size for backup, but now—when a single clip can occupy a whole DVD—you will find this impractical. A better alternative is to keep an entire project on an external hard drive and store the hard drive itself as the backup. You can keep costs down by using bare drives and a reader device (dock) which works in exactly the same way as a card reader, providing quick access to a hard disk and allowing you to dismount it and swap it as required.

When you've copied the files onto the backup drive and your main intended working location, you can begin to log your clips. This is an opportunity to review the material you've captured and reject unwanted clips. This part of the process might be assisted by using your editing software, depending on its features. Otherwise you could user a browser tool like Adobe Bridge to review the clips. You should refer to your shot list, storyboard, or plan if you've got one and rename the clips with their shot and take numbers.

When you're editing you'll want the files to be converted to the most efficient format possible (see Tip 95) and stored on the fastest hard drive possible, usually your computer's main or another internal drive. USB and FireWire—especially older FireWire 400—drives will work, but can be slow and laggy, which makes scrubbing through the video to perform edits frustrating, not to mention the risk of knocking the cable and causing a crash.

A standard hard-disk drive in a dock-style reader.

Start with a pile of your full memory cards.

Place each card into a card reader connected to the computer.

Transfer the files to the computer's internal hard drive and to an external backup. Make sure that any files with the same name don't overwrite each other.

Repeat the process with any audio files, placing them (at first) in a separate folder.

Begin transcoding (see Tip 71).

Start editing on a computer (ideally with backup to preserve edit, certainly with auto-save to protect against crashes!).

Export the video to output media, then archive.

✳ AVCHD

If your production has mixed sources, including a digital camcorder, the likelihood is that it shoots not in individual clips (though there will be individual clip files in there) but that it delivers a package of folders on the SD card. You can simply copy the whole package of folders to your backup drive, remembering to put them within a containing folder specifying the exact shoot and card (otherwise you might wipe it when you transfer a second card to the same location). Most editing software will be able to translate the package into an easy-to-understand format.

71

Transferring and re-encoding

The world of video file formats is more complex than you might at first imagine, and different cameras record different file formats. At least for the more sophisticated editing tools you may encounter, you'll find it hugely advantageous to "transcode" your footage from the camera's native codec into one more suited to editing.

This is not essential—and might not even be possible with more modestly priced software—but there is sound logic behind it. The in-camera methods of compression are generally designed to be space-efficient, like the H.264 system adopted by Canon. H.264 (like most other space-saving compression systems) uses interframe systems that, when played, tell the player the color of one pixel based on its color in the previous frame. Data storage is reduced by indicating that it has not changed, or changed only slightly, rather than describing a new color from scratch each time.

The editing process, in which you need to scrub forward and backward quickly through video, makes working from this kind of file very stressful on even a fast processor, as it has to retrieve several frames for each download you want to look at, and work out what the frame should look like on display.

To speed things up, files can be converted to an intraframe system, in which each individual frame is compressed, like a series of stills. The flipside of this is that because these systems don't take advantage of similar data in adjoining frames, they take up far more storage space. This, however, is less of an issue when you've got the files as far as a computer system and have access to hard drives.

H.264 also records in a 4:2:0 chroma pattern (the chroma pattern describes the the level of detail with which the color is recorded, with 4:4:4 the theoretical maximum, 4:2:2 a common high-end editing choice, and 4:2:0 capturing half that level of detail, ito save on storage space). Transcoding makes it possible to increase the chroma detail, useful when making fine color corrections.

If you've got a Final Cut Pro-based editing system and a Canon DSLR, you'll be able to download Canon's EOS Movie Plug-In in order to

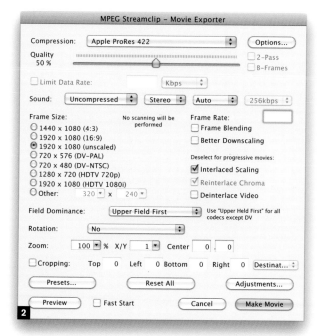

Intermediate codecs

There are a surprisingly large number of codecs out there on the market, though your choices will be restricted by your software and platform choices.

Apple ProRes
The standard for Final Cut Pro, Apple bundle this with the software and it is more than adequate for top-quality editing jobs, though the files created are considerably larger than the original camera files.

Neoscene
A cross-platform codec available for Adobe Premiere, Final Cut Studio, Avid Media Composer, and Sony Vegas. It uses its own interpolation algorithm to recover from 4:2:0 to 4:2:2 chroma.

XDCAM
The XDCAM formats create files of a similar size to the camera originals, which can still be edited with easily.

transcode footage using the program's standard log and transfer tool. They are converted to Apple's ProRes format, which makes real-time editing on a standard laptop a practical task, even from a USB 2 hard drive if necessary (though it's preferable to work with the onboard drive).

The other alternative is the free, cross-platform conversion utility MPEG Streamclip, which can convert H.264 files to more practical formats, and some say that it's faster than paid-for tools like Compressor.

As computers become more powerful, and are equipped with more RAM, the need to use these intermediate codecs becomes moot; certainly most editing programs will be relatively agnostic about the files that are imported, allowing you to edit material from several different devices. When it's possible to take HD quality (at least in resolution terms) video from a cell phone, it would be folly not to. HD video, though, is taxing, and as you become more ambitious with your editing, you'll find the intermediate stage is far from a chore (though it's certainly an opportunity to go and get some coffee).

72

Scratch disks

Video files not only take up a large amount of space on your hard drive, but because they are such large files, your computer needs a lot of space that it can temporarily write data to—what is known as a scratch disk. In use, a scratch disk supplements the RAM in a computer, so that once the RAM has been filled with data that the editing program needs to store temporarily, the computer has another location to store further information, speeding up the whole data transfer—and therefore editing—process.

If you intend to do a lot of video editing, it pays to have a fast, empty hard drive that serves only as a scratch disk. While even the new breed of super-fast hard drives, including Solid State Drives (SSD) cannot match your computer's built-in RAM for speed, they do have the advantage that they come in far greater capacities, so they work well as supplementary temporary data storage, especially for video files.

The reason you want to use an empty drive, rather than your main system drive or a data storage drive is because a hard-disk drive can only access one sector at a time, and unless the disk is "blank," it will be accessing the computer's operating system, your editing program, or your video files, as well as trying to read or write data to or from the scratch disk, which will slow the process down. You can usually specify a drive to use as a scratch disk from the Preferences panel in your video-editing program.

If you cannot use an internal drive—say you're using a laptop—make sure you use the fastest possible external drive. FireWire 800 provides excellent sustained data-transfer rates, while USB 2 Hi-Speed can still be a little laggy. Hopefully the emerging USB 3 specification will solve this.

A great advantage of desktop computers is that there is room to fit extra internal hard disk drives to the internal "bus." This usually makes them far faster to access than external drives. It's a good idea to keep your scratch files on a second hard drive—not the one your computer boots from.

Storage and backup

1

System HDD

Scratch

Store

Images Backup

Images Main

2

HDSLR video uses a lot of computer real estate, both in terms of the processing requirements and the amount of storage space it requires—remember, around 12 minutes of footage will take up 4 GB of space. Exactly how and where you store your files will depend on the amount of money you are willing to spend on storage, as well as the amount of data you intend to produce. At the top end of storage spectrum, you might run a dedicated file server, while at the lower end, you may simply copy the clips to the hard drive in your computer and work on them from there. No matter which route you take, the important thing to remember is that hard disks can fail—they only have a finite lifespan and will, at some point, give up, resulting in a total loss of all your work.

With this in mind, it is worth protecting yourself by having a backup of anything that is important to you. Backups can be as simple as a copy of a file

written to a DVD, or as complex as a fully redundant RAID array with offsite storage. When dealing with your video data you should come up with a solution that works for you, and one method is to base your video workflow on a system such as this.

If you have a very fast internet connection, you could also consider "cloud" storage for your more important work, or for finished projects. Cloud storage is essentially data space provided by large internet companies, such as Amazon S3 or Apple's MobileMe services. They allow you to store data on their servers for a monthly fee, which will protect you from any form of hard-disk failure or local disaster at your main storage location—most likely your office or home. However, if you have a lot of data to store or a slow internet connection, cloud storage can be expensive and time-consuming, so it's worth deciding whether it really is suitable for your needs.

1 An external hard drive.

2 Backing up your work regularly is good practice.

74

Editing software

1 Pinnacle

2 Premiere Pro

3 Sony Vegas

4 Final Cut Pro

To hear many professionals talk about video editing, you would think there were only a handful of programs available—Avid, Final Cut Pro and Premiere are names you'll hear a lot—but in practice there is a much broader range of tools out there, ranging from free to a good range at far more approachable prices than any of the tools mentioned above.

Your level of investment will reflect the features you need—some facilities are simply not offered by the less expensive packages—but if you're starting out with video, the most important skills are simply trimming clips and placing them in order, something you can do with any editing program, including some that won't cost you a penny.

Windows users can begin their experiments using Windows Live Movie Maker, a free cloud-based program that is available for download to anyone with a Windows Live ID (for example, MSN Messenger users or those with Hotmail addresses). Mac users can dive straight in with iMovie. Both programs have their limitations, neither offering the flexibility of multiple tracks.

For those willing to spend a small amount on their software, there is a fiercely competitive market, with established names like Pinnacle Movie Studio, Sony Vegas Movie Studio, and an emerging leader, Adobe Premiere Elements, which is a reduced-feature version of Premiere in the same way that Photoshop Elements is a cut-down version of the leading pro image editor. This approach has been adopted by Apple, too, with Final Cut Express

bringing much of the professional editing suite within reach of mere mortals.

These programs generally offer all that you might want in terms of editing tools when starting out, though will perhaps impose artificial restrictions on the number of tracks or the flexibility of some filters or effects. Where the cutbacks tend to be made is in the area of professional codecs

and exporting tools, since to keep costs low these technologies cannot be licensed.

At the top end of the scale are the names we started with, which offer all the flexibility you can dream of, and the ability to import and extend the features to suit whatever your project demands. On Hollywood projects it's not unknown for directors to commission their own software plugins and scripts to be written to tweak these programs to suit the project. Given the cost of a software spend such as this, it's incredible to think how much the core of these programs have in common with their Elementary (or Express) versions that cost a fraction of the amount. The choice is yours.

75

Initial settings

When you start editing your footage, it's important that you set up your editing software correctly. If that's not done, you'll find little glitches that get in the way, especially if you are using sound and audio from different sources. To some extent most software can make these choices automatically for you as soon as you copy over the first clip, but it's important to ensure that you have it set up the way you want, especially for mixed-source projects, in which case some of the material you include will have to be transcoded.

So, when you create a new sequence file, you need to remember to open its information panel and enter the timebase (the number of frames per second), resolution, codec, and audio frequency.

Unless you have a specific reason not to, you should use the same settings as you did in-camera or at least in the transcoding stage. That's because otherwise the editing program will be forced to render the clips to the new size or timebase as you edit, which will slow the process to a crawl, and reduce the amount of editing you can do in real time. (If you're not editing in real time, you need to wait for the computer to render your changes before you can preview them after each edit you make, which is far from efficient.)

One exception to that rule is that, if you're planning to output your video on a NTSC television, you can change the timebase from 30fps to 29.97fps, the rate of NTSC DVD and broadcast.

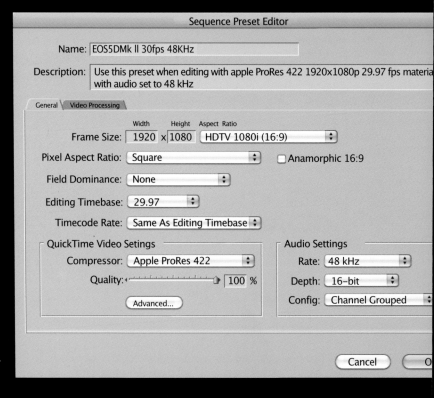

There are a number of key settings for any video project—clips from any source will be sealed to fit these specifications.

76

Log and Capture

The first stage of editing is to review your material and bring the clips that you want to work with into the editing program. This used to be an arduous process in tape-based workflows, even with DV cameras which could be controlled by the computer over a FireWire cable. Then the workflow was to mark all the clips on the tape that you were planning to use, before leaving the computer to wind back and forth and transfer the data to a digital format it could work with.

While it had its flaws, this step did have the advantage of being very straightforward, and by forcing you to copy the data over in this manner—it was the only way to turn the video into computer files—it guaranteed that you'd follow a sensible workflow, discarding material you didn't need and naming that which you did.

Now it's possible to sidestep this. You can drag the files onto your computer from the memory card and transcode them following the advice in Tip 71. It would then be perfectly possible to drop the transcoded files directly into an editing program, and indeed that might be how you are required to work.

The advantages of the "old" system, however, are such that most serious video-editing tools have adapted the Log and Capture feature for modern media. Final Cut Pro, for example, calls its alternative version Log and Transfer. It sits between the original files and allows you to review each shot, mark the section of the clip that you want to use (be generous—you may need extra seconds at either

end for sound editing or fades in the edit), give it a sensible label, and transfer it.

This means that only the sections of video that you absolutely need are placed into the "bin"—the selection of clips that your editing program presents you with when your adding clips to the timeline. An organized bin makes editing infinitely easier.

The Log and Transfer window allows you to review clips and copy over only what you need.

77

Clip-based editing software

1

2

Editing using a clip-based program requires you to trim each shot of your video to its beginning and end (see Tip 78), then place it in order in sequence. The market perceives these tools as easier to use, and this style of editing permeates the tools targeted at beginners, but it is clear and logical and perfectly adequate for many tasks, especially well-planned productions.

Where this approach struggles is with effects. While most will allow you to add titles to individual clips, or between them, which is great for simple explanatory text or graphics like maps, they don't allow the flexibility to finely control overlaid graphics.

In terms of speed, you will likely be able to start to work with your clips in one of these tools straight away, and producing a rough cut will take only as

long as it takes to remove the unwanted tops and tails of each shot. You can then review your material and refine your cuts.

Given the fierce competition in this area, you won't find yourself short of effects; transitions like patterned wipes, fades and even more specialized graphics are well covered, as are themed presets in which you place your clips in order and the program automatically adds effects to a style, like "Holiday".

These effects can seem decidedly downmarket, but it should be remembered that great directors like Hitchcock had little more at their disposal than cuts and fades, and with that they could create timeless cinematic masterpieces.

1　iMovie (Mac only).

2　MovieMaker
(Windows only).

78

In and out points

The principle of clip-based editing is simply that you import your unedited clips, usually into a bank or viewer in the editing program, then select a shot and play it. Using play/reverse tools (often a scrubber that you can drag backwards and forwards) you will be able to identify the place in the recorded shot from which you would like to use material. You can then mark this as the In point.

At the other end of the clip, you can set an Out point in a similar manner. This tells the editing program that this is as much of the clip as you want. You can

then add this to the sequence and repeat the process to add more and more shots to your project.

Setting the In and Out points doesn't mean that you delete the video that falls outside these points, but that it isn't used in the clip you transfer to the sequence. You can usually come back to the clip and extend it, though it's worth noting that In and Out points in the Log and Transfer process operate differently—only the highlighted section is transcoded, so it's worth making sure there are a few seconds spare.

The line beneath the viewer indicates the In and Out points. This program allows the audio In point to come before the video one, hence the split indicator and red line.

Creating a clip

Before

In and out points marked

Resulting clip

79

Multiple-track editors

2 How the simulated timeline shown below looks in Final Cut Pro. Each program will look slightly different, but the principles are the same.

Video	Stereo (a1a2)	Filters	Motion					
Name	Parameters		Nav		00:00	00:00	00:01:06:00	00:01:12:00
▼ Basic Motion								
Scale		120						
Rotation		0			432 −432			
Center	0 , 0							
Anchor Point	0 , 0							
▶ Crop								
▶ Distort								
▶ Opacity								
▶ Drop Shadow								
▶ Motion Blur								
1 Time Remap								

Non-linear editing (NLE) has revolutionized the work of video and cinematographic editors over the last few decades, and the software has now reached a level of maturity that makes it fit to handle projects ranging from family movies to feature films.

The main distinguishing features of a fully fledged track-based editing program like Final Cut Pro or Premiere, as opposed to the clip-based programs in Tip 77, is that they allow you to view your video in terms of layers, which work much like Photoshop's layers, but stretched along a timeline. You don't necessarily need to use more than one track to achieve a very sophisticated-looking edit, but it's an advantage being able to overlay effects and graphics as you choose.

In terms of your soundtrack, the flexibility of multiple layers is unparalleled. You can add numerous tracks, like the original recorded audio,

soundtracks, effects, and commentaries, setting different levels for each.

Although you'll find that you quickly end up taxing even the most powerful computer's RAM and storage resources, you can add numerous filters and effects to the content you add to each track, from simple drop shadows if you're placing text in a layer, to graphic effects, and more. Moreover there will be tools that allow you to alter the strength of these effects over time. That's because the timeline concept is extended to filters, effects, and basic geometry of any clips you add, and you can use key frames to indicate to the software that, for example, you'd like a clip to appear at 100% size at the first keyframe, and 120% size at the second. When played, this would cause the clip to apparently zoom in.

1 Some of the controls that can be applied to an individual clip. The Scale setting has been given two keyframes (green triangles) and the scale is set to different values at each. In between the two points the program automatically "tweens" the changes so that the animation is smooth.

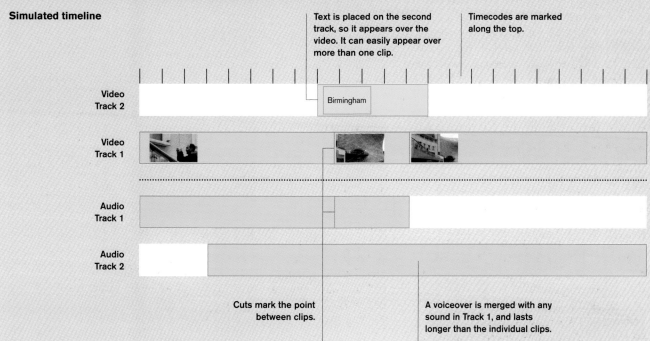

Simulated timeline

Text is placed on the second track, so it appears over the video. It can easily appear over more than one clip.

Timecodes are marked along the top.

Video Track 2

Birmingham

Video Track 1

Audio Track 1

Audio Track 2

Cuts mark the point between clips.

A voiceover is merged with any sound in Track 1, and lasts longer than the individual clips.

80

Cuts and fades

The cut, and then the fade in a distant second place, are the two simplest edits in filmmaking. In its simplest terms, the cut is an instantaneous change from one camera position to another. You will make a cut because the shot on screen has provided the audience with all the information it can and you want to move to another angle—perhaps closer—and ideally when there is a clear motivation (the character on screen finishes a point and it is another's turn, or they walk into a new location).

Cuts work best when the next shot is from a new angle (otherwise the subjects seem to judder as the location remains the same, which is unnatural), and if there is some kind of continuity of movement which masks the cut.

Fades, on the other hand, are more obviously unnatural, and tend to indicate the start and end of a scene (to or from black) or, in the case of a crossfade (or dissolve), perhaps to suggest the passage of time or the shift to a dream sequence.

1–6 In a track-based editing program, it's possible to vary the opacity of tracks. Here the black line represents the opacity, so the angled section is a fade from Clip 1 to Clip 2.

81

Transitions

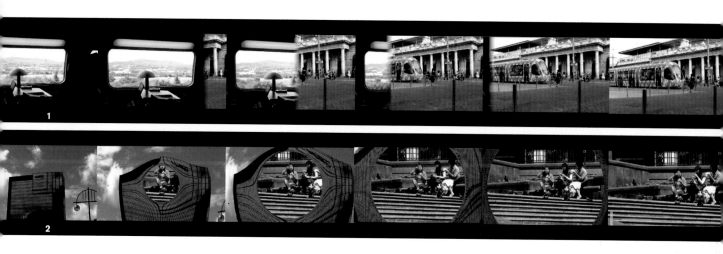

Beyond the crossfade, there are many more ways of animating the shift from one shot to another, many of which you'll be familiar with simply by browsing through the feature list of any editing application. Perhaps the most common is the wipe, in which a shape of some form is animated across the screen from one shot to the next, something anyone who has seen the *Star Wars* movies will be more than familiar with, though there are many who would argue that they're not really suited to narrative productions, especially the more obviously graphic wipes like the clock.

In a purely digital process, there is scope for all sorts of transitions to be defined beyond the classics. These can include 3D effects from page-curls to rotating cubes. All of these have their place; the page-turning might work if you were going to include stills from a book or simulated book, for example, and the 3D graphics might serve to make something look exciting, but they all run the risk of seeming artificial.

Too many transitions will distract from the story and the quality of the image, ruining all your hard work in getting the footage in the first place.

It's also good to remember that a transition doesn't have to be applied in the editing. Any movement when filming, for example a pan between two subjects, or a change in focus or zoom length, can also be thought of as a transition.

The best advice is to keep transitions simple and make sure the viewer concentrates on the film and not the techniques and technology used to create it—if the viewer is unaware of the cuts, then you have succeeded in keeping the story as the most important aspect.

1 A horizontal wipe effect, a relatively traditional transition.

2 A "3D" circular push transition.

82

Speed shift

When editing your footage, it is possible to speed up or slow down your clip for a dramatic effect. This is not the same as importing a 60p clip into a 24p timeline, but instead is done once the clip is imported. Adjusting the clip speed will make everything either move around faster or slower depending on what change you make. It can be a useful method of quickly telling part of the story, or of compressing sections into a smaller timeframe.

You can change the speed of the clip in two ways—either constantly, when the whole clip is adjusted equally, or variably, where you can change the speed of parts of a clip.

While a constant speed change will affect the whole clip, a variable speed change will allow you to slow down, then speed up, then reverse, then pause, then slow down again—or any combination of those. This variable speed change is known as time remapping because frames are moved from their original time to a new one.

In a more sophisticated editing program, you can use keyframes to change the adjustment speed so the video speeds up and slows down smoothly. Here, depending on the angle of the adjustment line in the motion tab, your video clip will run faster (steeper angle), slower (shallower angle), stop (horizontal line) or run backwards (descending line). You can make adjustments smoothly as well by using curves from the Pen tool's smooth point option.

Remember that because each clip only has a fixed amount of frames, if you want the clip to end at the same point, slowing down one section will mean you need to speed up another, otherwise the end point will be different.

1 Adjustment made in Final Cut Pro showing different rates of clip speed.

2 Original.

3 Speeding up means the computer simply skips frames, so looks smooth.

4 Slowing down video means frames need to be repeated, looking unnatural.

83

Mixed media

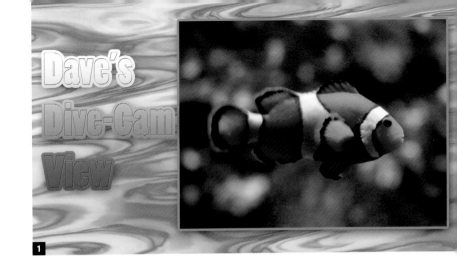

As noted in Tip 71, it's perfectly possible for editing programs to handle a wide variety of different digital sources—camera phones, Flip cameras, traditional camcorders, and more. Because they're digital, all of the information can be processed on your computer without recourse to processing services, assuming that you've got the necessary codecs installed on your computer. Many editing programs will accept these files with relatively good grace.

The problem is that all of these cameras produce video of widely varying quality; not just resolution, frame rate, and codec, but frequently even different aspect ratios—some sticking with classic TV 4:3, others at the more modern 16:9.

Therefore it's essential to make sure that your initial settings (see Tip 75) are correctly set. It's probably best to work at your DSLR's maximum resolution during the edit and, if you feel you need to bring it down later, do so when you compress your final project. That will leave you with the option of top-quality HD for the final project, but if you feel that some of the scenes from other cameras are so jarring in comparison, you can bring the whole project down to something else, perhaps 720p.

You can deal with different frame sizes in one of two ways: to crop in (at the expense of resolution and some of the image data), or to place bars down the side of the screen. Having these pop in and out of an edit is incredibly distracting, so you should only use it in a context your audience will understand, for

example if you explained that they were about to see eyewitness camera-phone recording and it was the best quality available.

A further step is to design some kind of graphic for differently shaped or lower-resolution clips and to play them within a frame. It might, for example, say "helmet-cam" if we were switching to a presenter's POV camera attached to their head. Viewers understand that these cameras have to be of different quality, so can forgive it, and—in the right circumstances—it makes them feel like they're being treated to a bonus.

1 A low-resolution diving camera's view shown over a static graphic.

2 The flip camcorder is a great tool for getting extra digital footage with the minimum of fuss.

84

Cropping

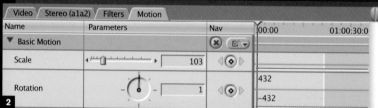

Cropping your images is standard practice in the land of stills, but making serious crops with the kind of HD video produced by digital SLRs is only acceptable when you're stepping down to standard definition. Assuming you're not planning on degrading the video quality, you should limit yourself to cropping to around 80% of the original frame.

At this sort of scale, you will be able to apply a gentle sharpening filter to restore image quality to something close to a standard 1:1 crop. Your editing program may do this for you, but if not you'll find a sharpening filter among the options available. Tread lightly, as it can be exaggerated by compression algorithms, creating unpleasant artifacts.

Another kind of crop you might want to make is to change the format of your video to cinematic 2.35:1. You can do this at the export stage, and to give yourself handy guides while editing (and leave yourself the 16:9 option) you could create the bars as a graphic with an alpha channel and place it on the highest track in your editing program, and turn its visibility on and off as you wish.

1–3 Scaling up a video clip, thereby cropping it, makes it possible to rotate the clip to correct the horizon (but it's a lot easier to use a tripod with a spirit level.)

85

Smooth Cam

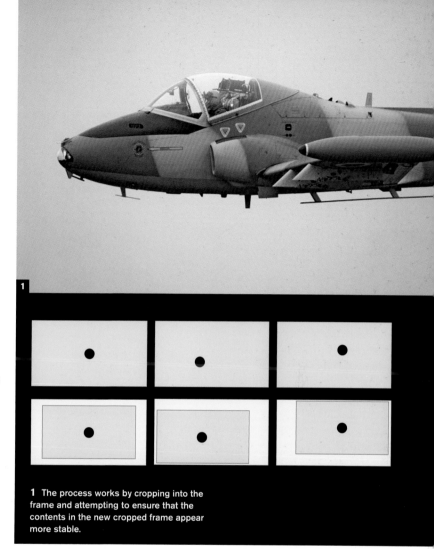

An extension of the principle of cropping your video to make corrections is the Smooth Cam feature (though it goes by different names). This process takes advantage of the power of modern computers to analyze each frame in comparison with those before and after it and attempts to eliminate any vibrations, smoothing out the shot by adjusting the crop so that your subject's movement is smoother.

All this is far from instant, even on powerful computers, since the algorithm needs to be able to determine any movement that should have been happening—for instance a pan, or a moving subject—and separate it from the vibrations that it needs to correct. It also makes use of cropping, which means that there is a quality issue.

All that said, it can go a long way to making a shot look significantly more professional, and can be a great boon for budget productions where an impromptu dolly—a skateboards or car window, for example—has been used. It is also useful if you've taken a shot in windy conditions where buffeting is visible despite using a tripod, something which is especially likely at high zoom and if you're using a lighter tripod designed for stills photography.

The best advice is not to think of this as a magic bullet; do your best to forget it's possible when you're shooting, but be grateful it's there if it turns out you don't have any better shots to use.

1 The process works by cropping into the frame and attempting to ensure that the contents in the new cropped frame appear more stable.

2 With SmoothCam processing, be prepared for a wait; this is not something you'll want to do on all clips.

Visit www.web-linked.com/vidt/85/ to see a before-and-after example of this feature.

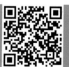

86

Using images in your movie

The camera you're using is not just great for shooting HD footage. It is originally a stills camera and is therefore capable of producing great still images you may wish to use in your film. If you do want to use stills, make sure you resize them before importing them to your project. For an HD video you don't need the full resolution of your still camera and using it will only slow down your editing, as the software will need to use bigger files and take more time rendering data as you make changes or apply filters. If you resize images to 3840 pixels on the longest edge, this is double the horizontal resolution of full HD footage, giving space to pan and zoom

around still images—if you know you don't want that much space for panning or zooming, or indeed don't want to pan or zoom at all, you can simply resize to smaller dimensions.

Since you've probably edited images and resized them for display on the web or screen, you probably sharpen your images for output. It's OK to sharpen your images a little for video, but use much lower values than you normally would. If you over-sharpen an image and then display it in video, it can look very unnatural—you're better off with an under-sharpened image for video.

1–2 In your editing program, you will need to define the size and position of your virtual camera at the beginning and end of the clip. The computer will synthesize a smooth pan and zoom between the two for the duration you set.

3 In the example above, a 1920 x 1080 crop from a larger photo can represent a small percentage of the overall area and maintain pixel-to-pixel detail. The original still is 18 megapixels.

87

Green screen and chroma keying

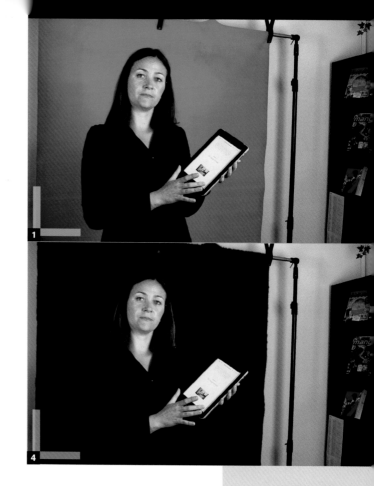

The technology that allows you to place people in other worlds is now within anyone's reach, and if you doubt that, just check the list of features included in Apple's iMovie, which comes free with every Mac. It's also a standard feature of many other editing programs, and is known more properly as chroma keying.

The principle is very straightforward: shoot your subject against a green background, which can be identified by the computer in editing software and removed. Green is an excellent choice because the bayer pattern on most camera sensors has twice as many green sites as red or blue, and—perhaps more importantly—because we rarely wear it. "Green," however, is a pretty vague term, and computers are a lot happier with specifics.

To get the best-quality green you'll be correctly advised by many to select a foam-back green-screen fabric (the foam helps prevent the fabric creasing) and lighting it evenly from both sides. The aim is to narrow the range of greens that are seen by the camera, making it easier for the software to select the foreground from the background. For photographers, the process is analogous to using Photoshop's Select Color Range tool.

While professionals will speak about the lengths that must be gone to in ensuring perfect lighting and the absolute evenness of the fabric, in practice the software has now reached a point where it is better able to handle less-than-perfect conditions. That's not to say you should cut corners, but it's nice to know you can work on a smaller budget if necessary.

The key point is to make sure that your subject stands far enough away from an evenly colored surface (it doesn't have to be green) so that they do not create a shadow on it. Using an aperture that keeps your subject in focus but softens the background is great too.

With the right software, you can adjust the chroma (hue) that the computer keys in on, and the width of the range of both the chroma, saturation, and brightness. In situations where you can't easily light the whole surface evenly, widening the range of accepted brightness will work well, whereas if you had to compromise on the quality of the fabric, widening the chroma range will be more effective.

In track-editing software, you will be able to apply a chroma-key filter to the subject and place it in a video track above your background. There might be additional filters or adjustments to help handle the potential halo effect around the edge of your subject; experiment with these but don't go overboard—a slight halo is better than a person appearing with fuzzy ghost-like edges.

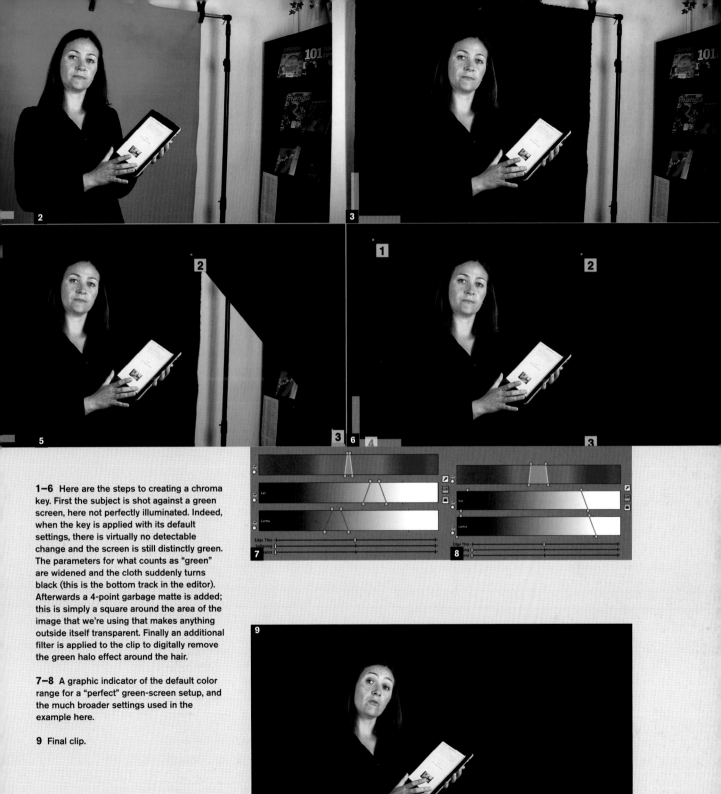

1–6 Here are the steps to creating a chroma key. First the subject is shot against a green screen, here not perfectly illuminated. Indeed, when the key is applied with its default settings, there is virtually no detectable change and the screen is still distinctly green. The parameters for what counts as "green" are widened and the cloth suddenly turns black (this is the bottom track in the editor). Afterwards a 4-point garbage matte is added; this is simply a square around the area of the image that we're using that makes anything outside itself transparent. Finally an additional filter is applied to the clip to digitally remove the green halo effect around the hair.

7–8 A graphic indicator of the default color range for a "perfect" green-screen setup, and the much broader settings used in the example here.

9 Final clip.

88

Audio tracks

In iMovie's equivalent
of a timeline, an overlaid
audio track can continue
beyond individual clips
and is presented as a
line extending from its
starting point.

Editing with audio
tracks in Final Cut Pro.
Note the pink lines with
keyframes representing
volume level, and that
each track is shown as
a Left/Right stereo pair
with waveform.

We've already said that sound is half of video, but that isn't strictly true; in most cases it's more than half, in that an audience is far more forgiving of a less than perfect moment of video than it is of a problem with the soundtrack. An unwanted electric hum, clicks, pops, even the talent's intakes of breath are noticed and every problem either destroys the suspension of disbelief in a movie, or just makes your production values look poor for everything else.

Editing sound with tracks goes a long way to simplifying the process of creating beautiful sound, allowing you to carefully control the apparent volume of each individual sound in your production, just like a mixing desk on a timeline. In the case of the editing software, though, the timeline is the same as the one you're editing your video in (assuming you're using a track-based tool), which means you can perform additional edits like L-cuts, in which the sound from one shot overlaps with another in order to minimize the jarring effect of a cut.

Programs that allow you to edit with tracks will usually allow you to view the waveform that represents the volume of the audio track. This is incredibly helpful from an editing standpoint, as you can see clear visual clues to certain moments in people's speech, which in turn allows you to fade down an audio track where it isn't needed.

Less sophisticated editing tools will usually also offer the option to overlay some audio tracks— perhaps a commentary or some music—but it will be represented differently. The disadvantage is that they do not usually allow you to make adjustments to the volume based on the content or exact timing.

Most editors will also allow you to individually alter the volume or levels of the left and right stereo tracks if you choose, in order to position a sound source from the right location. In some cases you can create multi-track surround-sound productions using additional tracks, though these are quite specialized skills.

Editing with audio tracks

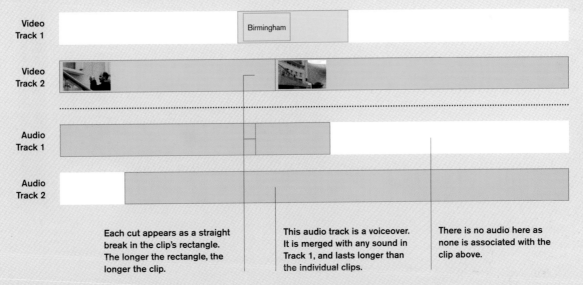

Video Track 1: Birmingham

Video Track 2

Audio Track 1

Audio Track 2

Each cut appears as a straight break in the clip's rectangle. The longer the rectangle, the longer the clip.

This audio track is a voiceover. It is merged with any sound in Track 1, and lasts longer than the individual clips.

There is no audio here as none is associated with the clip above.

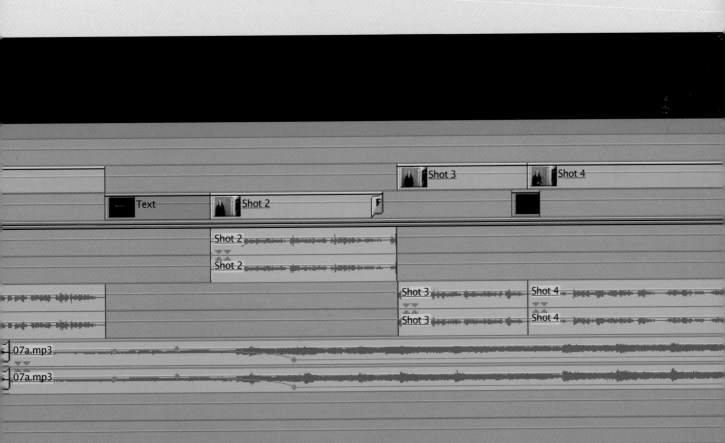

89

Audio levels

Getting your audio levels right is vitally important to making sure you have the best quality audio with no clipping. In the same way that you lose information in an image if you overexpose the scene, so setting the audio level too high will cause popping and distortion that lowers the quality of your audio. You should pay attention to your audio levels both at the time of recording and also when you come to edit in your editing software.

Most editing software will show you audio meters that display the levels of your audio track, regardless of the volume setting on your computer. These meters are numbered in decibels and will range up to the loudest sound at 0dB. Both when capturing audio and when editing, you should aim to have your audio tracks peaking somewhere between -18dB and -12dB. If you venture much above -12dB for long periods of time, you will enter

the orange/red zone where distortion and tone clipping can occur. If your audio drops much below -24dB, the levels will be very low and your viewers will need to turn up the volume to hear anything. This is fine for short periods of time—during a quiet section of your film, for example—but the main audio when you want the viewers to be able to hear what is going on should be set around the -12dB mark.

Maintaining these limits in the edit is essential. You'll also need to balance the levels of overlaid audio tracks, which can be individually controlled. This is an opportunity to increase or decrease the volume of imperfectly recorded sound to return to the magic -12 to -18dB zone: take it.

1 The Audio Levels diagram in an editing program is similar to the one you'll see in-camera or on recording equipment.

2–4 In the diagrams below, twin stereo tracks—track A left and right, and track B left and right—are shown in an editing program. The pink lines indicate their levels. In diagram 2, track A (narration) can just be heard above the music in places but only because words are so distinct to our ears. In diagram 3, the volume is lowered for the B (music) track, and is virtually inaudible. The tiny upward adjustment in diagram 4 provides a nice balance.

Repairing sound

We'll start by saying that—as was mentioned in Tip 58—there is no way to fix sound recorded at the wrong levels. If it sits in the red zones near 0dB or below -24dB, the chances are you'll have to start again from scratch. That is why so much emphasis is given by professionals on getting the sound right first time; it's really the only chance.

Even a good-quality recording, however, will likely need further tweaks before it's ready for the big and unforgiving speakers of a television. For one thing, in regular human speech there will be regular intakes of breath and other sounds that we simply filter out in our minds, but cannot if they're played to us loudly on a speaker system. It doesn't seem fair— the microphone was listening to the same person speaking—but that's how it goes.

Anyway, while it can't perform miracles, there are two techniques you can use to dramatically improve even a good-quality recording. Both are based on a "noise print," which is why it's always vital to get a few clear seconds recording when no one is speaking. The print is a section of clear background sound which you can tell the computer to look at and either analyze for unwanted noise, which is then removed from the entire recording, or use to replace moments of bad sound.

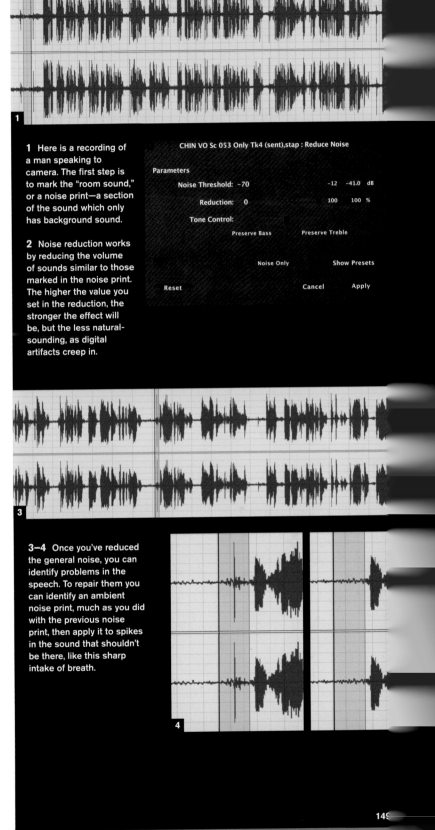

1 Here is a recording of a man speaking to camera. The first step is to mark the "room sound," or a noise print—a section of the sound which only has background sound.

2 Noise reduction works by reducing the volume of sounds similar to those marked in the noise print. The higher the value you set in the reduction, the stronger the effect will be, but the less natural-sounding, as digital artifacts creep in.

CHIN VO Sc 053 Only Tk4 (sent),stap : Reduce Noise

Parameters

Noise Threshold: -70 -12 -41.0 dB

Reduction: 0 100 100 %

Tone Control:

Preserve Bass Preserve Treble

Noise Only Show Presets

Reset Cancel Apply

3–4 Once you've reduced the general noise, you can identify problems in the speech. To repair them you can identify an ambient noise print, much as you did with the previous noise print, then apply it to spikes in the sound that shouldn't be there, like this sharp intake of breath.

91

Color grading

1 A color-grading tool which allows you to adjust the tone (from white) and brightness of shadow areas, midtones, and light colors separately. Filters like these have to be set and applied to each clip.

Sadly many people now refer to color grading simply as color correction, but that somewhat diminishes its purpose. The latter emphasizes the importance of imposing consistent color across clips, but with skilled use the same tools can be used to subtly alter the tone of a clip too.

If you want to be creative with color, it's likely you have a plan for altering the tone and color of your footage—for example, to add an orange hint in order to make the picture seem candlelit and warm. That's certainly something that you can do with these tools—that's the "grading" aspect, if you like—but the correction is key, and equates more directly to using the Levels or Curves tools in Photoshop to make sure that first, you've got a good shot, and second, that your subsequent shots match it.

If you had a lighting disaster, for example, and switched to a different color temperature, you can also make this change here (you can also make cloudy days sunny, and vice versa—see Tip 52). If you remembered to use a gray card or color checker, it's as simple as clicking on the eyedropper icon and then on the mid-gray on the viewer. If, however,

you've been lazy at the point of capture, you will pay for it now by having to grade all your clips independently and trying to get them to match.

Because color correction is done on a clip-by-clip basis, and is heavily dependent on the qualities of the preceding and immediately subsequent clip, it should be done after you're happy with your edit. It's a chore, but one which will stop audiences from questioning what they see.

Depending on your choice of software, you will find a variety of different methods of color correction, from the simplest sliders for color and saturation up to complex, three-way color wheels that allow you to individually adjust shadows, midtones, and highlights.

Color is monitored using a tool sometimes called the "scopes," with each scope having its own particular purpose. The principal of these are the Vectorscope, which indicates the tendency toward certain colors, and the Waveform, which acts much like a live-action histogram.

All the monitors shown here provide different ways to check whether the colors are up to scratch. The four here are shown reflecting the standard color bars; the Vectorscope shows brightness from the center and color in a hue circle— each bar appears as a spot, as it is a large area of a single hue and brightness. The line near the Red marker is the fleshtone line.

The Histogram works just like any other (see Tip 46). The Waveform monitor shows the luma (effectively brightness) of your shot in vertical lines from left to right. The RGB Parade does the same thing, but splits the image into three for the RGB primaries.

The three circles give a clue as to how the Waveform and RGB Parade works; in the monochrome waveform you can see a white mark at 100% where the purely white circle is. The central area approaches white in the middle, but this actually reflects the white at the bottom of the circle, and the hues are translated into their respective brightness (the difference can be determined in the Parade).

In a practical example, where the tonal shift is more natural, the Waveform simply shows that there is a good range of shades (and hence tonal detail) across the image.

Vectorscope

Histogram

Waveform Monitor

RGB Parade

Vectorscope

Histogram

Waveform Monitor

RGB Parade

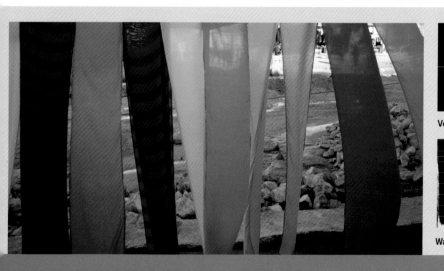

Vectorscope

Histogram

Waveform Monitor

RGB Parade

92

Broadcast safe

If your video is going to be broadcast on television, you need to make sure that the colors and brightness (or white point) are acceptable to the broadcaster who will be transmitting it. The problem with this is that all broadcasters define their own standards, so you need to find out what an individual broadcaster considers to be "broadcast safe" before you send them anything. If you don't, and your work doesn't match their criteria, it will likely be rejected.

Most professional editing software has the option to apply broadcast-safe filters to the footage when you finish editing. These filters adjust the colors and brightness so that they fall within a specified range, but you need to make sure this is the last thing you do to your footage after all the other editing and color grading/correction; if you apply filters and then do further color correction, you may find that your adjustments push the brightness or saturation above the initially "safe" level.

The best way to ensure that the broadcaster displays your video as intended is to use bars and tone at the beginning of the tape or file that you send. They will probably insist on this anyway. The bars include a full white (100%) area and a totally black (0%) area which equate to the lines in the color-grading scopes seen in Tip 91. Notice that the charts indicate an area above or below 100%—this is the area to steer clear of.

The bodies that enforce these standards are the Federal Communications Commission (FCC) in the United States and the European Broadcasting Union (EBU), though from your perspective it'll be the broadcaster buying your work.

On the plus side, the technical complications of black and white levels expressed in terms of the analog signal is really a thing of the past as new broadcast systems like DVB-T and DVB-S (Digital Video Broadcasting Terrestrial and Satellite) are able to switch between streams like MPEG2 and MPEG4 (or even data like text pages), as the broadcasters choose. You just need to submit the requested file type.

1 Waveform monitor.

2 A broadcast tower.

3 Remember to add bars and tone to the beginning of any clip you send to a broadcaster. The white square should represent 100% white, the black 0% (true black), and the tone should be -18dB.

❋ NTSC (525/60i)

Vertical resolution: 525 (480 visible)

Horizontal resolution: 720 (or 640 square)

Aspect: 4:3 (720 wide can be 16:9 anamorphic too)

Frame rate: 29.97 (59.94 fields)

Black level: 7.5 IRE (US)

White level: 100 IRE

❋ PAL (625/50i)

Vertical resolution: 625 (576 visible)

Horizontal resolution: 720 (or 640 square)

Aspect: 4:3 or 16:9

Frame rate: 29.97 (59.94 fields)

Black level: 0 IRE

White level: 100 IRE

❋ HD

Vertical resolution: 720 or 1080

Horizontal resolution: 1280 or 1920 (always square pixels)

Aspect: 16:9

Frame rate: various

Levels: various

93

Graphics

1 A selection of graphics in Apple's iMovie.

2 A graphical sequence.

Adding graphics to your video is very simple. Making them look good is another matter. In many respects, this is actually an area best served—certainly in terms of bang for your buck—by the cheapest programs on the market. Many of these include beautifully designed and animated templates to which you can add your own words if you choose, and which look great. The only real problem is that, after a while, you'll run out.

At the other end of the scale, producing graphics for video is generally perceived as being a different task from shooting and editing, with a different skill set and different software tools. Apple's Motion and Adobe's After Effects, for example, are tools that both firms will bundle with their editors, and have useful linking features so you can create preset designs and switch between the editing and design programs to tweak a design.

3–4 iMovie, in common with many editing programs, has an array of pre-designed effects which look good, or serve a particular need, but aren't very flexible.

94

Lower thirds

The climb - day 1

1

Day 2: City center

2

City center

Day 2: City center

The most useful graphic you'll come across is the "lower third," named after the area of the screen in which it is placed. These are used to explain something to the viewer—the name and function of the person speaking, details of the location, the time a new scene takes place, and so on.

The only real "rule" is that the words should stay on the screen (not including any animation at either end) as long as it takes you to read it three times. This gives slower viewers the chance to take the information in, but does not allow it to stay on screen long enough to become boring.

In the past, you would be warned at length about the title-safe area, which was essentially based on the idea that graphics placed too near the corners of a frame might not be seen, as some lines are lost at the top and bottom of CRT TVs (some even rounded the picture corners off). In reality, this factor is determined by your audience; in most cases, modern televisions crop very little of the picture, and designing your graphics for a safe area can make them look strange. If your video will only be viewed on the web, there is even less cause to be concerned about the safe area.

1–2 Animated graphics are now commonplace and can liven up a production. Take care to use them consistently.

Feature Film / Edmund Curtis *Senet*

1

2

Senet is a low-budget thriller set on the streets of London. It follows the journey of a young Cypriot breaking into the crime underworld of England's capital. The film was co-written and directed by Anthony Petrou and shot by me on the Canon 5D MkII on a five-week schedule.

Having a background in digital stills on the Canon 5D MkII, I was making the leap forward into making motion pictures with the camera. This was my third project using the DSLR as a movie camera, after two previous music videos.

I was approached and interviewed by the producers and was told that they had already decided to shoot on the 5D for budgetary reasons—and in the current climate, who could have blamed them? It was Anthony's personal passion project and he hoped that the film's success would snowball into further projects.

The pre-production process of the film was very different to any project I had previously worked on. The team—which also included camera operator

Olli Collins—was very DIY-orientated and even before I joined the project an array of homemade jibs and cranes had already been assembled out of aluminum pipes and nuts and bolts. We wanted a highly stylistic, compelling story with high production values at the lowest possible cost (doesn't every film?)

The production had also invested in various accessories for the Canon, including matte boxes, tripods, a follow-focus system, steadicam and a set of Zeiss primes. We rarely had to hire in extra equipment. We wanted to have a portable unit that we could set up almost anywhere to achieve our shots, as we were usually working with inexperienced crew members and limited time.

Having previously worked on films where the physical size of the equipment was much larger, the choice to shoot on DSLR proved both beneficial and detrimental in different ways.

Originally the camera crew consisted of myself, the camera operator, focus

puller and 2nd AC. However, early on in the shoot, I could see that at the speed we were working, there were too many of us around the camera for a film of this size. With much larger cameras it is necessary to have a dedicated 2nd AC to help move and maintain equipment, but with the DSLR often I would quickly just reposition the camera myself, reframe, and be ready to go for the next take. This was particularly helpful as it sped up the production, which also helped the actors' flow. Often, Anthony would ask me to find a nice frame for a reverse or a close-up and I was simply able to lift the camera from the tripod plate and line the 5D wherever I pleased, placing it right against a wall or in cramped positions—a tremendous benefit over larger, bulkier cameras.

The camera's portability and light weight also made it possible for our own DIY camera equipment to be used. Over the course of the production, camera operator Olli Collins had been perfecting his homemade jib arms, dolly track, and

highlighted brilliantly in these night exteriors shot purely with available light.

3 Home-made 20-foot jib made from aluminium tubing and other hardware parts. The camera's weight was of major benefit in making our own equipment.

4 Home-made dolly was perfect to setup quickly when time was tight.

3 4

comfortable with such a setup. Since shooting the film, though, I believe there are now options to output to two separate monitors. It would be a lot more beneficial if this could be done in-camera.

Another problem we encountered only came to light after viewing the first two

miniature tabletop dolly, and even managed to construct a full 30-foot crane, complete with remote tilt head. We were able to own a complete camera package, including all accessories, for under £5000 ($8000). With many larger formats it cost that much to hire the equipment alone—shooting on DSLR is therefore a very cost-effective way to produce a feature film.

However, there were some problems that we came across during the production.

At the time of production, the 5D's external monitoring options were very limited. Once Live View is activated on the camera, only the external monitor or the camera's LCD could be viewed at any one time. This meant that either I could see the shot comfortably to film it, or Anthony could see it, but it was not easy to see the shot together. This proved frustrating at times. However, we had a trusting relationship and Anthony was happy for me to operate from the monitor so that he could focus on the performances. This was a trusting relationship that worked very well for us,

days of rushes. During the shoot, we were externally outputting our video to a 7-inch monitor thorough the HDMI output. As our lenses were mainly still lenses used for digital photography, the focus markings on them were not particularly accurate. Looking through the 7-inch monitor, images appeared to be in focus, but when we viewed the same footage on a larger HDTV screen, this was often not the case.

This last problem was the most serious that the production encountered. Much of the footage from those first two days had to be reshot and we soon invested in a Marshall monitor for the production. In hindsight, a good monitor is possibly the most important accessory for DSLR filmmaking. The Marshall monitor in particular had a "peaking" function which, when activated, would show which parts of the image were in focus, enabling the whole crew to work more easily.

Another problem encountered was that when you are not recording, the Live View function can only be activated for a short

then the Live View button must be pressed again. This can be particularly frustrating when practicing dolly and crane shots, as the picture would cut off halfway through the practice move.

Regarding editing, the 5D records in the H.264 compression format, which is a very unstable format to edit. At the moment, only Adobe Premiere can natively edit this codec. We used Final Cut Pro, so all the footage had to be converted to Apple ProRes 422 before editing. This greatly increased the file size, but even after this conversion file sizes were relatively small in comparison to other filming formats I have used before.

All sound had to be recorded externally, as the 5D only has a small, 3.5mm jack input for sound, which compromises good sound production. Visual and audio had to be synced in post, and we used a program called Pluraleyes (a Final Cut plugin) that automatically synced the sound provided you recorded onboard sound through the 5D's internal microphone. This proved to be a great time-saver.

Having seen the completed project, several conclusions can be made regarding the use of DSLRs as professional filmmaking equipment.

The DSLR must be treated like any other film camera. Expose your image correctly, employ a good camera team that understands the camera, understand the camera's limitations, and, above all, create visually stunning images that help anchor the narrative. The DSLR is just like any other format, it is simply another filmmaking tool with its own benefits and limitations.

Visually stunning images can be produced with this method and the DSLR revolution has some incredible benefits. However, the same filmmaking principles still apply and are even more important in DSLR filmmaking.

Chapter_ 05

Publishing

95

Export for computer viewing

100%—110.4 MB

Watching video on the computer screen might not seem the most glamorous of possible final destinations for your great masterpiece, but certainly the first place you'll see your video is on your computer, and computers—or other computer-like devices—are now the mainstream. Indeed, for many people, more of their leisure time is spent looking into a laptop than a TV screen.

Obviously your computer is capable of displaying video if you've got as far as completing an edit, but as part of the process it was likely transcoded to a space-consuming format. When you're preparing the file to be viewed on the computer—or computers—you will be looking to use an established but efficient codec. The aim is for the video to be as compact as possible, while maintaining the maximum quality.

If you're planning on distributing your video, you need to be aware that the highest quality that your computer can play might be a little out of reach for others, so if you're going to send the video to relatives, for example, consider tweaking the settings to reduce the resolution—or, if you have to, halve the frame rate—which will make the video considerably less processor-intensive. Changing the level of compression without changing the method will likely have little effect on required power; H.264 requires more CPU power than MPEG 2, but is less space-efficient.

Within a specific codec, this change of compression is usually thought of in terms of bitrate, which can either be fixed or variable. In the latter case, when you encode the video the computer will endeavor to use a lower rate when there is less action, and therefore less changing detail, on the screen. In the H.264 examples shown here, the bitrate is expressed as 0–100% (the minimum and maximum allowed by the specification).

1 Devices like the Apple TV are increasingly common, and in addition to allowing video to be streamed from the internet, they also allow you to store video on a computer elsewhere in your home and access it from a family space without the usual clutter of computer connectors.

75%—30.9 MB

50%—10.4 MB

25%—5.6 MB

0%—3.7 MB

✻ Commonly supported formats

Memory Stick Video Format
* ✻ MPEG-4 SP (AAC LC)
* ✻ H.264/MPEG-4 AVC High Profile (AAC LC)
* ✻ MPEG-2 TS (H.264/MPEG-4 AVC, AAC LC) MP4 file format
* ✻ H.264/MPEG-4 AVC High Profile (AAC LC)
 MPEG-1 (MPEG Audio Layer 2)
 MPEG-2 PS (MPEG2 Audio Layer 2, AAC LC,
 AC3 (Dolby Digital), LPCM)
 MPEG-2 TS (MPEG2 Audio Layer 2, AC3 (Dolby Digital), AAC LC)
 MPEG-2 TS (H.264/MPEG-4 AVC, AAC LC)
 AVI
* ✻ Motion JPEG (Linear PCM)
* ✻ Motion JPEG (µ-Law)
 AVCHD (.m2ts / .mts) DivX
 WMV
* ✻ VC-1 (WMA Standard V2

✻ Computers vs. TVs

Many computer monitors are a slightly squarer 16:10, rather than 16:9, in their proportions, which means that very small black bars will appear at the top and bottom of the computer screen when viewing HD video.

Though it's your choice, if the video is only likely to be viewed on computer, 720p resolution rather than 1080p is often sufficient, as the monitor is rarely the exact same pixel dimensions as a 1080p TV, so some scaling, with slight softening effect, will occur anyway.

96

Online publishing

1 Creating your own YouTube channel is a great way to get your video out there, and to encourage viewers, once hooked, to see more of your work.

Once you've edited your movie, one of the widest-reaching distribution methods available to you—and certainly one of the easiest—is the internet. However, publishing online can also be problematic. Although the content is still your copyright, it is hard to protect, and it is easy for people to take it and re-use it. This should not put you off using the internet as a means of distributing your movies, but you need to be aware of the risks so you can try and minimize them.

There are lots of websites where you can post your videos, but the two most commonly used at the time of writing are Vimeo and YouTube, both of which will host high-definition, 720p footage, as well as standard-resolution video. Each has its own particular approach; YouTube is a general site with videos posted from a wide variety of sources, while Vimeo is more of an enthusiast's site with a smaller, but more advanced membership that makes it better suited to sharing creative video work. This is not to say that YouTube should be only be considered for "basic" videos, as it will most likely generate a larger number of views, but if you want to share your work with, and get feedback from, a more sophisticated audience, Vimeo is the better choice.

To ensure your video is compatible with both, you need to make sure it is saved in the correct format and has the correct compression settings. Fortunately, if you make a video that you can upload to Vimeo, it will also upload to YouTube. YouTube's original "native" video format uses

Flash's compression system, so your video will be transcoded after you send it, before it goes live on the site—a process that might take some time, and does have potential quality concerns. Adobe's Premiere Elements sharing tools can send native files, however.

Another potential problem with online publishing sites is their automatic features for detecting copyrighted music. They act in a manner which presumes guilt, so it's possible to upload a video and, if you don't check it, find that it only plays with the sound disabled. The copyright scan might not happen at the point of upload, but a later date, so don't think you can escape the licensing powers. If you have bought the copyright, the onus is on you to make this clear to YouTube via their counter-notification procedure.

Finally, remember that once you publish your video, that isn't the end of the story. You, and others, can add comments which can even appear over the video itself, depending on the user's settings. This is as much a community as anything else—far from a perfectionist's medium. You can disable these features, which will likely reduce the chance of your video "going viral" (word-of-mouth leading to increased hits), or you can take the hit.

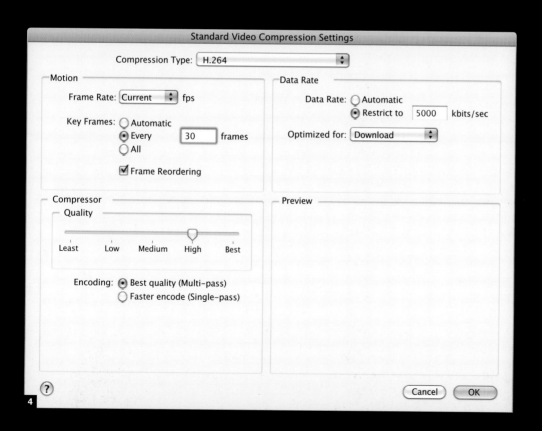

Sound Settings

Format: AAC

Channels: Stereo (L R)

Rate: 44.100 kHz

☐ Show Advanced Settings

Render Settings:

Quality: Normal

MPEG 4 AAC LC Encoder Settings:

Target Bit Rate: 128 kbps

Cancel OK

Settings...

● 480p
360p

480p

2

3

✳ Settings

These are the settings for the two leading online video sites for uploading HD video.

✳ **YouTube**
H.264, MPEG-2 or MPEG-4 encoding
720p resolution
44.1KHz Stereo as MP3 or AAC/WAV
Use original frame rate
Max. file size 1 GB / 10 minutes

✳ **Vimeo**
MP4 preferred container
H.264 encoding (5000bps)
720p or 1080p resolution
44.1KHz AAC/WAV stereo (320kbps)
Use original frame rate
Max. file size 1 GB / 10 minutes

2–4 Most compression programs allow you to set a preset, so you can check the most recent advice from your preferred sharing site. Here, the settings for Vimeo are being added to Apple's Compressor—the same as the details given in the box.

Standard Video Compression Settings

Compression Type: H.264

Motion

Frame Rate: Current fps

Key Frames: ○ Automatic
● Every 30 frames
○ All

☑ Frame Reordering

Data Rate

Data Rate: ○ Automatic
● Restrict to 5000 kbits/sec

Optimized for: Download

Compressor

Quality

Least Low Medium High Best

Encoding: ● Best quality (Multi-pass)
○ Faster encode (Single-pass)

Preview

Cancel OK

4

97

Web formats

1 The iPhone has been a key player in the future of video on the web.

2 The first five pages of the 641-page HTML5 specification draft from WC3, the organization that drafts World Wide Web standards.

Beyond the established video sharing sites, embedding video into web pages has become more and more common, in advertising, tutorials, and more. As of 2010, brewing tensions about the best format have become out-and-out war as Apple and Adobe, and to some extent Google, raised the dispute from angry message boards to artillery.

The story is essentially this. In the early days of computer video, files had to be sent separately over the web and viewed in separate player applications. It wasn't very straightforward, and not everyone had the player programs. Then an upgrade to the already well-established Flash plugin (an extension to the web browsers which is built-in, so virtually transparent to the user) created a format which quickly became dominant. Video could live in, and be controlled from, web pages, and all was fine so long as the user had the Adobe Flash plugin and creators used Adobe's tools to encode their video. Since Flash has close to a 100% installed base in computers, it was barely questioned.

But two things have happened more recently which may have scuppered Flash's effective dominance. The first was the emergence of a set of standards adopted by web standards committees, which incorporated video (based on H.264) into "HTML5," a package of extra features to the standard for web documents which major browsers—even traditional laggard Internet Explorer—are expected to support within the next year or so. Firefox and Safari already do.

Nonetheless, from a creative standpoint, web developers already have a working piece of software in the form of Flash and, all things being equal, its position would likely have remained unchallenged, regardless of the worthy arguments about openness of standards. Apple's iPhone, though, can be seen as the first torpedo to hit Flash's side.

The iPhone sold very well, and now has successors and competitors, and many of these don't support Flash (and Apple have made it very clear that they plan not to). This wasn't an immediate problem, as people were happy to forego some things on the move, but the arrival of the iPad—still without Flash support—has created an environment in which are a lot of influential web users are simply unable to view Flash content.

At the time of publication, this is an ongoing debate, and it's possible that devices that do support Flash will come to dominate the market (some handsets based on Google's Android system can).

Incidentally, Google, too, have a preferred web video standard, but its traction is relatively minimal. Called WebM, Google have released their codec as a perpetually royalty-free tool, whereas the owners of H.264 have reserved the right to charge for fee-paying uses of H.264 (but haven't done so).

98

Intertextuality

Although in the multimedia age the word itself is something of an anachronism—it refers to the relationship between two "texts"—the concept of intertextuality is more important now than ever. In preparing your video you need to be conscious of its part in an overall strategy, for which you'll need a great deal of clarity from your client if you're working on video to be included in a website, for example, as your graphics will have to match those of the site that surrounds them.

If you're shooting a video to promote a product, you'll also need to make sure that the "environment" inside your piece is correct from the point of view of your client, and doesn't feature anything contradictory to their brand image—not just competing products, but details like heavy metal CDs lying around in the back of shot that might not go down too well.

In the more traditional artistic sense of the word, creative filmmakers might want to extend the concept of intertextuality beyond creating a consistent look to referencing and making nods to more famous creations in their own genre. This is a great link into promoting your work on the internet, thanks to the influence of keywords. The dolly-zoom's inherent links with Alfred Hitchcock were mentioned earlier; if you make use of the effect, be sure to mention Hitchcock in any video metadata. This will increase the chances, however slightly, of someone stumbling upon your YouTube clip instead of another, and eyeballs are the object of the exercise. If you're shooting a number of pieces for whatever purpose, think about creating links through whatever resources are available to you, for example the YouTube channels feature.

On a lighter note, the world is filled with parodies—it's the basis of the comedy in films like the *Scary Movie* series. Why not try shooting your own parodies as a means of learning and developing?

99

Portable devices

1

2

3

Preparing video for portable devices is not as challenging as it might first sound. Indeed, if you're happy to relinquish any level of control then it's very likely that the software supplied with your device (for example iTunes) will be able to re-encode your video to a scale it considers appropriate and add it to your library or transfer it to your device.

Portable devices, however, all have limited capabilities and you might want to exercise your own control over the exact balance of the quality-versus-size compromise. If you're targeting a specific device, you might even want to scale/crop the video to the exact pixel dimensions of the device in question so there's no wasted space or data. This might be a little short-sighted though, with the abundance of different devices and crop sizes that exist on the market.

Just one manufacturer (though admittedly one of note in this area), Apple, has different screen shapes on its iPod Touch/iPhone lines in comparison to its iPad lines, and have never settled on a screen shape for its smaller iPods. And that's just a drop in the

ocean; the massive variety of phones and media players out now and to come will all feature screen sizes designed to suit the needs of the product as a whole, not just its video-playing function. Device manufacturers will generally solve your problem for you, though, by letting the user choose to crop the film on the center portion or view with black bars.

The former is the most problematic from an artistic viewpoint as it's quite possible that, if your subject appeared artistically close to the side of your frame, they are cut across the face. You can avoid this when shooting by keeping important characters and details near the center of the screen, or by painstakingly cropping key shots in your edit to create a new "pan and scan" edit, as was traditionally done in the conversion from cinema to TV.

Such details are an artistic choice. In terms of getting your material out there, it's best to simply leave that to the viewer, set the compression to a medium value, and use the widely recognized .M4V container file with H.264 video and AAC or MP3 audio.

1 The Apple iPhone is a popular choice.

2 Nokia have a range of video-capable phones.

3 A wide range of different media are playable on this Samsung.

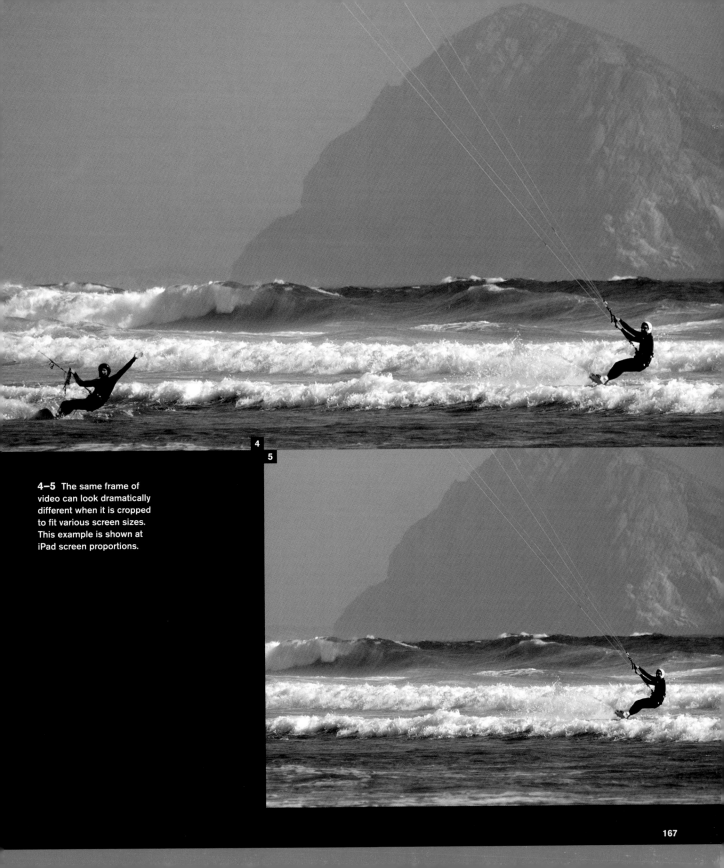

4

5

4–5 The same frame of
video can look dramatically
different when it is cropped
to fit various screen sizes.
This example is shown at
iPad screen proportions.

100

DVD

1

Though the Blu-ray lobby has had a hard time making it obvious to consumers, DVD-Video is not actually a high-definition format. Data DVDs can, of course, store any kind of computer video file, including high definition, but DVD-Video is a specification (which includes a menu system designed to be easily operated from a remote control, and a storage system allowing multiple languages and subtitle tracks). It was designed for consumer players and dates from before high definition was mainstream.

To distribute your project on DVD you'll need to convert it using an authoring program which creates files readable by DVD players. Mercifully these tools are often included with editing software (iMovie has its counterpart iDVD, Final Cut Pro has DVD Studio, Permiere has Encore, and Premiere Elements has an output to DVD option). These programs come with menu templates, or—with varying levels of sophistication—allow you to customize the menu designs.

There is actually a surprising amount that you can do with the DVD specification. Alongside simple subtitling and additional soundtracks (commonly used for director's commentaries and foreign languages), DVD players all have a (very limited) memory which can, with care, be used to create DVD quiz games that keep score.

A word of warning about DVDs: they must be encoded in NTSC for the US and Japan, or PAL for most of the rest of the world, with all the attendant

issues about frame rates and resolutions. The files should be encoded in MPEG 2 with a maximum bitrate of 9.8Mbps (10.08 including audio, which is encoded separately as an AC3 "Dolby Digital" or other audio format). Too low a bitrate looks bad, and creates quality problems.

This is a separate issue from the optional regional coding that restricts the territory in which a DVD will play. The latter is a measure used to enforce copyright, as all DVD players have a native "region" and a DVD may be encoded to play in one, some, or all of these regions. For personal or small-scale distribution, you need not worry about this.

1 A DVD player.

2 DVD Studio Pro and other top-tier DVD authoring packages like Encore (opposite) support the full use of features such as multiple audio tracks, subtitles, graphical subtitles, and so on, but still come with pre-designed templates for those in a hurry.

2

101

Blu-ray

The consensus is that Blu-ray will have the dubious honor of being the last physical media format, since digital distribution over the internet seems likely to become more practical as connection speeds improve. That's an uncomfortable position to be in for a format still establishing itself after emerging from a bitter battle with the other proposed solution to the "need" for a format capable of holding a feature-length movie in high definition.

HD-DVD arguably had the most consumer-friendly name, and big backing in the form of names like Toshiba and Microsoft, but the latter failed to put their money where their mouth was, and only included a DVD drive in their XBox 360 games system. Sony, one of the chief backers of Blu-ray, did feature the (then very expensive) drives in their competing PlayStation 3 games system, which created enough critical mass to ensure there are a few Blu-ray shelves in most music and video retailers, and the players are affordable.

Authoring is more problematic, as the format includes a great deal more flexibility than DVD, and the specification has been extended by version numbers since launch, though that has now settled down. In terms of software, Adobe Encore (part of the Premiere Pro package) is capable of mastering both Blu-ray and DVDs. The software can encode the video to the best possible standard for you.

As well as software, you'll need a Blu-ray drive with write capability and writeable discs, neither of which are cheap or very common, even on new computers. Apple users will have an especially hard time with the format, since the company has shown no enthusiasm for the format. Blu-ray drives can be sourced from other suppliers and fitted to Macs, but software support is minimal—there is no Blu-ray player in the operating system.

1 A Sony Playstation 3.

2 The Adobe Encore authoring tool.

Chapter_ 06

Index

Gamut The limits of the range of color, or color space, that a certain device operates in. For example, the eye might see a green far more vivid than the image sensor can—this would be "out of gamut".

HDMI (High Definition Multimedia Interface) A digital consumer level standard, now the standard, for carrying HDTV signals from devices like cameras or video sources (Blu-ray players, games systems) to display devices. There have been some revisions since the first launch, and the latest, 1.4, includes 3D and 4k support.

HDTV (High Definition Television) The broadly accepted definition is 720p or 1080i/p resolutions, the next commonly used broadcast standards after NTSC/PAL ruled for 50 years.

HDV An HD format that uses DV tapes and supports 720p and 1080i.

Interlacing The principle of increasing resolution by updating only half the picture with each frame.

Live View mode The system in an SLR which allows the mirror to remain up and the imaging sensor and LCD display to work as an electronic viewfinder, just as in an EVIL or a compact-style camera.

MJPEG (Motion JPEG) A collective term for a codec in which each individual frame is recorded using the standard JPEG compression system. In video, this is not a very efficient system.

NTSC (National Television Standards Committee) More commonly the name given to the 29.97 frames per second color TV system it gave to the world (though only the USA, Japan, and some South American countries accepted the gift).

Offline editing Editing with a program other than the final editor to prepare an EDL; for filmmakers this is a job for Premiere or Final Cut Pro.

Online editing Editing with pro equipment at the final production quality, sometimes from an EDL prepared using cheaper offline editing tools.

PAL (Phase Alternating Line) Created in 1963 and introduced in 1964, PAL is an analog encoding system as commonplace in Europe and much of the rest of the world as NTSC is in the USA. It has a 625-line and 50 Hz signal, with 576 lines of picture and the rest to carry signals including captions and

text pages. Developed after NTSC, it was deliberately designed to avoid the need for manual tint control—it is from this "phase alternation" of the color component of the signal that PAL derives its name.

Pixel (Picture Element) The smallest component of a digital video frame, a square or rectangle that can be any color.

Progressive Progressive scanning is, theoretically, video in which the whole frame is captured each time, just as with old-fashioned film. (There are certain technical limitations with CMOS sensor cameras.)

QuickTime A video container file system (.MOV files) and the name for Apple's video player application. The QuickTime application offers additional features, such as the ability to create video from still frames, in its pro form, or is a free download for Mac or PC as a simple player.

Shutter speed effect The problem, especially with old movie cameras which used disk shutters, that if the shutter speed was set to longer than half the frame rate (i.e. 1/48 sec at 24fps) light would escape and damage adjoining frames. Because this rule has stood for a long time, breaking it now (e.g. 1/100 sec for 24fps) can look unnatural.

Slate The information board, or clapper board, held up to the camera to indicate the shot being taken.

Standard Definition The NTSC or PAL 480i or 576i video systems, in comparison to HDTV.

SLR (Single Lens Reflex) A camera type in which the photographer looks through an optical viewfinder and sees through the same lens that will take the final shot, via a mirror and a pentaprism. The mirror moves out of the way when the shot is taken. In video mode, these cameras must move the mirror out of the way and instead use the imaging sensor as an EVIL (cf) style viewfinder instead.

Stream In digital terms, this means to send a file so that the recipient can start to play it before the file has started to download, a common feature on sites like YouTube which stops things getting too boring.

Time lapse The shooting of frames over a long period then speeding them up so that events seem to have taken place faster than realtime.

Track Equivalent to layers in a program like

Photoshop, tracks are used in video-editing tools to overlay video and graphics or multiple audio sources.

WMV (Windows Media Video) A more modern video container format (than AVI) from Microsoft.

Y, R-Y, B-Y Luminance and color difference signals, as opposed to RGB. The Y is the luminance.





Glossary

3:2 pulldown The process of converting a 24 frames per second video to a 60 (or 59.94) version. One frame of the 24fps source is used to fill three fields (interlaced frames) of the 60fps output.

4:1:1 Any system of SD or HD video in which the ratio of luminance and chrominance (light and color) samples is 1 color to every 4 luminance (technically these are "color difference samples" in a digital signal).

4:2:2 Any system of SD or HD video in which the ratio of luminance and chrominance (light and color) samples is 2 color to every 4 luminance.

4:4:4 A system where all the information in the video signal from all three channels, Red, Green, and Blue, is maintained.

720p A high-definition video format of 1280 width x 720 height, presented in square pixels with all pixels updated with each frame (progressive).

1080i A high-definition video format of 1920 width x 1080 height, presented in square pixels with every other row of pixels updated with each frame (interlaced).

Active shutter The system of 3D television which shows in quick succession the left-eye and right-eye fields of view, and simultaneously blocks the view from the wrong eye using a pair of 3D glasses synchronized wirelessly with the television. The advantage of this over the system common in cinemas is that you can tilt your head without a ghost image appearing.

Anamorphic This describes a system where one format is squashed into another, and would look distorted if viewed without the appropriate conversion. An anamorphic was often used by DVDs to use every line in a SD video signal, but looks wrong on older 4:3 TVs.

AVCHD (Advanced Video Codec High Definition) Sony and Panasonic's recording format for digital video camcorders and similar devices. It is platform-agnostic (works on memory cards, hard drives, and so on) and has been adopted by other manufacturers.

AVI (Audio Video Interleave) Standard container file for video on Windows computers, and now many other devices.

Bit rate See , but especially used to describe audio tracks.

Blu-ray Launched in 2006, a CD/DVD-sized disc format which can store up to 50GB per disc, enough for a feature film in HD quality.

CCD (Charge Coupled Device) The image-sensing technology used by some digital still and many digital video cameras. Unlike its rival CMOS, CCD can record a whole image at once, rather than in progressive lines.

Channel In a stereo or surround audio recording, the individual recordings are said to be channels, for example Left and Right channels.

Codec (enCOder DECoder) A system for encoding and decoding video, essentially a file format for a digital video file.

Component video An analog video signal that is capable of supporting HD. Luminance and chrominance are kept separate, which helps maintain quality.

Compositing Layering video clips (as well as graphics and images) to create one video stream from many layers (tracks).

Compression In video, compression is usually of the lossy variety, meaning that some data is discarded in order to reduce the data used. Compression is sometimes described in terms of a ratio, for example 4:1, meaning that the new video is only 25% the size of the uncompressed version.

Container A file type that holds video and audio information together, typically a video recorded in a codec (e.g. MP4) and audio in another (e.g. MP3). AVI and QuickTime are containers.

Contrast measurement autofocus A system of autofocusing that can work even in Live View mode as it is calculated digitally from the image recorded by the imaging sensor.

Data rate The measurement of computer storage consumed by one second of video, measured in kbps or mbps.

dB (Decibel) For the purposes of this book, a measurement of audio volume level (though technically it can apply to any logarithmic ratio measurement).

Dolby The labs responsible for a number of sound compression technologies, including AC-3, the default on DVDs, as well as earlier systems like Surround and Pro-Logic which embedded extra channels into an analog stereo system (only one rear surround channel, though commonly through two speakers). Only Dolby Digital (AC-3) allows discrete channels, typically (but not necessarily) in the 5.1 Front, Center, Right, Rear Left, Rear right, and low frequency pattern.

DVB (Digital Video Broadcasting) Usually followed by -T for terrestrial systems or -S for satellite, this is a set of standards for broadcasters.

Downconversion/downsampling The conversion from HD to SD, for example to place on a DVD for delivery to clients.

DoP (Director of Photography) Also known as the cinematographer, this role is generally associated with the art/lighting aspects of shooting.

Drop frame The change in the timecode made so NTSC (which runs at 29.97fps rather than the mathematically convenient 30), dropping two frame numbers after the ninth minute of each 10.

DV (Digital Videotape) Format from the standard-definition era, with either MiniDV or DV tapes storing identical data.

EDL (Edit Decision List) A term from editing software, describes a list of time codes of in and out points to be assembled into a final edit.

EVIL (Electronic Viewfinder Interchangeable Lens) A camera which has the interchangeable lens of an SLR, but dispenses with a SLR mirror mechanism in favour of a electronic viewfinder only. This is effectively Live View, so video recording is possible in all such cameras.

FireWire Also known as IEEE.1934 or i.Link, this is a type of connector common in older video cameras and external hard drives and popular in the video industry thanks to its sustained high-speed data rates and inclusion on most DV camcorders. Comes in original 400mbps and faster "FireWire 800", the latter of which has a different-shaped socket.

Frame rate The number of times a second the whole picture is updated on the screen (so 50i is 25fps, while 24P is 24fps).

Reference

Acknowledgments / Photo Credits

ADAM JUNIPER

Once again, this book is for Jules, without whom life wouldn't be the same, and to mum and dad many thanks for graciously supporting the quest for video equipment long before I understood the value of it (or money!). Many thanks, too, to Natalia at Ilex for providing just the right balance of support and, er, encouragement throughout, as well as Tara for her tireless editing and checking, and James keeping the look and feel of the book on track.

FROM DAVID NEWTON

David would like to thank his better half Rachel Williamson for her continued support, www.top-teks.co.uk for their help with this project and the team at Ilex Press for its assistance and guidance. David provides training in both photography and DSLR videography, and can be contacted through either of his websites at: www.EOS-Network.com or www.photopositive.co.uk

WITH THANKS TO CLIVE AND ROB STREETER

Thanks go to the Streeters, who contributed some of the tips. Find more of their work at:

www.clivestreeter.com/

www.robstreeter.co.uk/

PHOTO CREDITS

Courtesy of iStockphoto (www.istockphoto.com): p10, p20; Courtesy of (www.kobal.com): p115; Courtesy of Fotolia (www.fotolia.com): p2, p11, p15, p29, p31, p38, p39, p40, p41, p45, p49, p50, p51, p52, p53, p54, p57, p58, p59, p62, p65, p93, p94, p98, p152, p167, p168.